IMAGES
of America

WASHINGTON
COUNTY

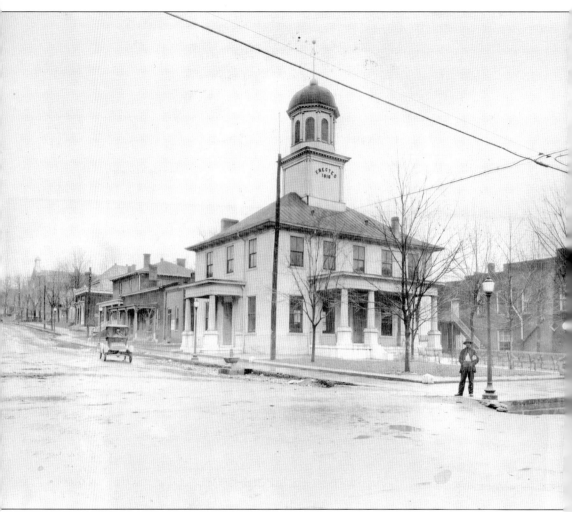

WASHINGTON COUNTY COURTHOUSE. Built in 1816, the Washington County Courthouse, located in Springfield, is the oldest courthouse still in active use in Kentucky. In this photograph, an unidentified man stands at the street corner in front of the building in the early 1920s. Records of the marriage of Abraham Lincoln's parents are still kept in the courtroom. Copies of the original documents were donated in the 1930s to the National Archives in Washington, D.C. Springfield received a grant in 2007 to transform the courtroom of the Washington County Courthouse into the Abraham Lincoln Ancestral Museum. (Kentucky History Center.)

ON THE COVER: The Tucker homestead on Grundy Home Road near Fredericktown, also known as the "Burg," was the home of John Absolom Tucker, who is seen here sitting on his favorite horse, Red, in 1912. Nora Estelle, one of the Tucker children, is holding the other horse. Standing nearby in a white dress is Mary Florence Phillips. The Tucker and McIntyre families took her in as a child because her parents were deceased. Her seven siblings were split up among farm families in Washington and surrounding counties. She was never sent to school and never married. Mary Phillips became the cook, housemaid, nurse, nanny, gardener, and seamstress for four generations of the family. The other people in the picture couldn't be identified. (Nick McWhorter.)

IMAGES
of America

WASHINGTON
COUNTY

Annette C. DuPont-Ewing

ARCADIA
PUBLISHING

Published by Arcadia Publishing
Charleston SC, Chicago IL, Portsmouth NH, San Francisco CA

Printed in the United States of America

Library of Congress Catalog Card Number: 2007929241

For all general information contact Arcadia Publishing at:
Telephone 843-853-2070
Fax 843-853-0044
E-mail sales@arcadiapublishing.com
For customer service and orders:
Toll-Free 1-888-313-2665

Visit us on the Internet at www.arcadiapublishing.com

This book is for my children, Julianne and Phillip, and for my husband, Tony. It is also for my parents, George and Julia Dupont, who came to this country and Kentucky to give their children a better life, and for Glenn and Patricia Ewing in appreciation for their help and devotion to their grandchildren. And finally, this book is dedicated to the good people of Washington County.

CONTENTS

ACKNOWLEDGMENTS

A debt of sincere gratitude to Billy and Betty Jane Cheser, Bobby and Mary Martha Cheser, and Helen Gabhart, who spent hours with me going through photos and helping me create a unique and historical look back at Washington County. Their generosity and kindness of spirit made this book a labor of love.

I owe a special thank-you to PNG for the historical review and editing of this book. I also owe thanks to all those who provided photographs and special assistance, including Rev. Chris Allegra, Mary Barber, Teddy M. Boone, Bob Bottom, Pam Breunig, Dorothy Buckler, Sr. Rosemary Cina and St. Catharine Motherhouse, Mary Lynn Clark, Ollie Gray Pinkston Clark, Peggy Devine, Bernadette Dupont, Julia and George Dupont, Louise Dupont, Kathy Elliott, Rev. Trumie Culpepper Elliott, Glenn and Patricia Ewing, Bill Graves, Pamela Grundy, Devola Moore Haag, Gwinn Hahn, Nell Haydon, former mayor Mike Haydon, Jean Lawson, Nick McWhorter, Jeff Moreland and the *Springfield Sun*, Louise Nally, Diane Newcomb, Jane O'Bryan, Wayne Pinkston, Larry Randolph, Mary Helen Russell, Janet Dawson Smalley, Laurie Smith, Joyce and Buddy Taylor, Taylor Spaulding, Bettie Walker, Betty Jane Wheeler, and Norma Jean Yankey. Those that loaned photographs for inclusion in the book are designated with a credit line.

This book would not have been possible without significant assistance from the citizens of Washington County. I would like to thank the individuals who trusted me with their families' heirlooms, their links to the past, and greatest treasures—their pictures!

INTRODUCTION

Washington County is steeped in tradition and heritage. If you ask people why they live in Washington County, they will often say, "It's a great place to raise kids." The people I've met have opened their homes and hearts in welcoming me to Kentucky's first county. There are a lot of things that Washington County doesn't have—no movie theaters, no Starbucks, and no mall, to name a few. And people like it that way. The presence of those things would somehow take away from an early morning stroll down roads that the Lincoln family used, and somehow would dull that small-town beauty that inspired the novels of Elizabeth Maddox Roberts. There's one thing that the people here do have: an appreciation for life's simple pleasures. They know the value of family traditions, visiting with friends, and taking the long way home to enjoy the countryside.

What struck me most as I wrote this book was the strong sense of community and fellowship in Washington County. These are families with passion, courage, grit, and—most importantly—a vision for the future of Washington County and the lifestyle they want to maintain. Washington Countians have a deep appreciation for the rich history of the county and an even stronger understanding of the importance of preserving it. There is an overwhelming sense of pride in the community and a determination to have both life's simple pleasures and progress at the same time. I hope this book captures some of the lost moments of the past that allow us to walk down Main Street and see it through the eyes of those that helped make Washington County the wonderful place it is today. Looking back allows us to remember making sorghum, hand churning ice cream, attending the high school football game, and hoping for a stolen kiss at the Mount Zion Covered Bridge. Looking back allows us to remember who we are and to drink in life's simple pleasures.

Named after the first president of the United States, Washington County is best known as the site where Nancy Hanks and Thomas Lincoln were married in 1806. Their original marriage license and other documents were donated to the National Archives. A copy of the marriage license hangs in the Washington County Courthouse, the oldest courthouse in continuous use in the Commonwealth. Washington County continues to play an integral part in the National Lincoln Bicentennial Celebration.

First settled in 1778, Washington County is easily cut into two distinct areas: north and south. The northern part of the county has cascading wooded hills, and the southern half is flatter and more easily farmed. The northern part is primarily Protestant, and the southern part is predominantly Catholic. And southern Washington County contains the major population center and county seat, Springfield. Originally Washington County was made up of 35 separate villages or communities; today it is anchored by three incorporated towns: Springfield, Mackville, and Willisburg.

Education and religion are intertwined in much of Washington County. One-room schoolhouses dot the landscape of Washington County and the pages of this book with pictures of barefoot children in coveralls. Some children started their education in those rooms, and for some, the eighth grade would be the extent of the education they received. Because of a shortage of teachers,

the Dominican nuns of St. Catharine College not only taught in the parochial schools but in the public school systems as well.

Established in 1822, St. Catharine Motherhouse was the first community of the Dominican sisters in the United States. St. Rose Priory, founded in 1806 was the first Catholic educational institution west of the Alleghenies. Jefferson Davis, president of the Confederacy, received part of his education at St. Rose, which was at one time the center of the community. In later years, each town had its own school system. A fierce competition among the teams of Mackville, Willisburg, and Springfield made high school sports spirited community events. Even though the county's schools were consolidated in the late 1960s, there still exists a healthy rivalry among the three communities.

In a county of only 10,000 people, those you went to grade school with were the same people you grew up with, got married to, and grew old with. That has since changed, but the old mentality of "families helping families" that was a necessity for farmers to survive has been retained. As is the case in most small towns, that closeness fosters an intimate knowledge of one another's lives, including failures, successes, marriages, and deaths. There are a variety of well-known people associated with Washington County. Gen. Matthew Walton was a Revolutionary War soldier, a Kentucky statesman, and a U.S. congressman. He is known as the political father of the county. Springfield also is well-known in sports and racing history. Native son Phil Simms was a quarterback and Super Bowl MVP for the New York Giants. Paul Derringer, who pitched in four World Series, and John Simms "Shipwreck" Kelly, a college and professional football legend, both were born in Springfield in the first decade of the 20th century. Kalarama Rex, an American Saddlebred legend, stood at stud at Kalarama Farm in Springfield for decades. Sedgefield and Dominican, the first horses from Washington County to run in the Kentucky Derby, are from Silverton Hill Farm outside of Springfield.

Edward Polin was one of the first African Americans to enlist in the all-white U.S. Marine Corps. The courage of Louis Sansberry, a 27-year-old slave who stayed to bury the dead during a cholera epidemic when the rest of the community had fled, is unmatched. Elizabeth Maddox Roberts was a Springfield native and wrote *The Time of Man* and *Great Meadow* in the 1920s. The Dominican Order of Sisters and the Dominican Order of Priests found their humble beginnings in the United States in Washington County, Kentucky.

Washington County is largely rural. Located equidistant from the larger communities of Louisville and Lexington, Washington County has been able to enjoy the amenities of a big city at arms length while maintaining some of life's simple pleasures at home. This book is not filled with photographs of famous people but with images of everyday people doing everyday things. Great acts of courage and duty have been executed by Washington County's people, from those who served in the Korean War and Desert Storm to those whose daily actions and activism—sometimes imperceptibly—improved the quality of life for future generations.

A book like this cannot come together without a lot of help. I have met so many wonderful people and charming characters. In conclusion, I believe that Washington County is blessed. Its strongest asset is its people, their strength, and their understanding of what makes life worth living. Whether or not you were born in this unique place, lived or worked there, or even if you're just curious about its past and its people, I hope you enjoy this work as much as I have enjoyed putting it together. I will always have happy and lasting memories of Washington County.

One

LIFE'S SIMPLE PLEASURES IN WASHINGTON COUNTY

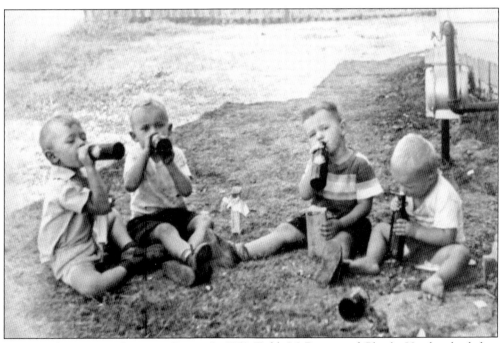

ORANGE CRUSH AND CRACKER JACKS. In 1953, Teddy M. Boone and Charlie Haydon, both four years old, sit on the ground with Mike Haydon, three years old, and Joe Pat Haydon, two years old, enjoying Orange Crush and Cracker Jacks. Good friends, good food, and plenty to drink—what more could these little boys want on a hot summer day in the backyard of the Haydon residence on Lebanon Hill Road? (Teddy M. Boone.)

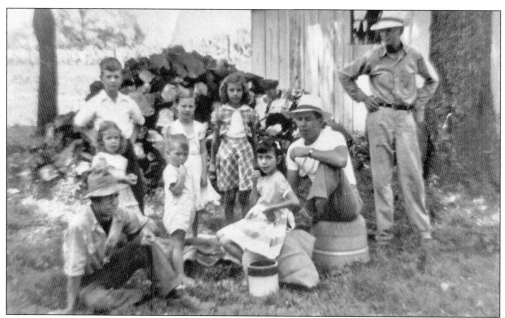

HOMEMADE ICE CREAM. After waiting for hours, nothing would taste better to these children than hand-churned ice cream in the summer of 1950. From left to right are (first row) Dorchester Hardin, Jerry Hardin, Norma Jean (Hardin) Yankey, William E. Hardin, and Russell H. Hardin (standing); (second row) Ruby Clellan Chesser Sagrecy, William Chesser Jr., Peggy Hardin Hayes, and Ruth Ann Hardin. (Norma Jean Yankey.)

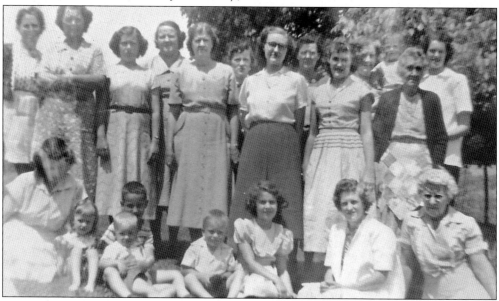

A LADIES' BREAKFAST. The Mackville Homemakers Club met in 1951 for breakfast on the porch. Seated from left to right are Wanda Matherly (by daughter Susan), the Lane children, Joe Settles, Rosemary Yancy, Jewell Settles, and Ressie Settles. Standing from left to right are Dora Shewmaker, Bertie Raybourne, Lois Raybourne, Wilma Anderson, Mable Shumaker, Norma Settles, Martha Bottom, Esther Simpson, Pat Lane, Faye Carey (holding Doug Elliott), Ida Masters, and Violet Elliott. (Violet Elliott.)

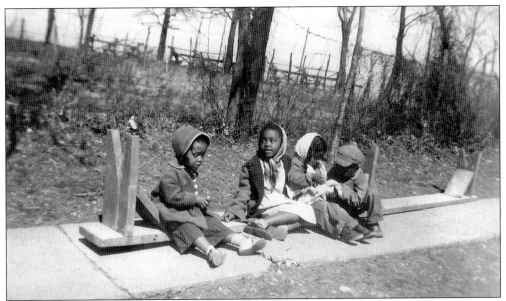

TIME OUT. Taking a break from playing in the yard on Briartown, from left to right are Julia and Rebecca Spalding, Rita Wright, and Andy Spalding. Charles Spalding had 17 children. He later became one of the first African Americans in Washington County to join the Knights of Columbus. Julia, Rebecca, and Andy are the children of Charles and Mary Hamel Spalding. Rita Wright is the daughter of A. B. and Rosella Wright. (Pamela Grundy.)

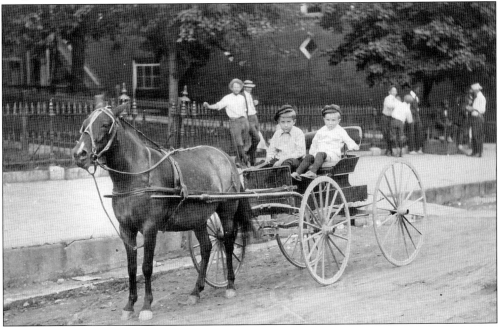

WROUGHT-IRON FENCE. Sitting in the horse-drawn buggy in front of the Washington County Courthouse are Charles Wells (left) and James Wells. Their father, Henry Wells, leans on the fence talking to a friend. The wrought-iron fence was later donated to the war effort. The building that housed the Starving Artist Café, Riedel's five-and-ten store, Riedel's Restaurant, and Thompson's Restaurant is on the right in the background. (Nick McWhorter.)

11

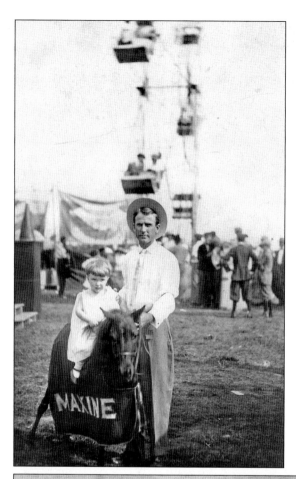

MARY AND MAXINE AT THE FAIR. H. L. Wells stands in front of the Ferris wheel holding his two-year-old daughter Mary Wells (McCabe) on a pony named Maxine at the Washington County Fairgrounds. Children could have their picture taken on the pony while at the fair. Mary Wells later married H. A. McCabe and had two sons, Jim and Ron. (Nick McWhorter.)

SCHOOL CHILDREN'S TICKET

Washington County Fair—August 27, 1937

certifies that _Darold Foster_

16 ___is a duly enrolled pupil in my school.

'ict No. _19_ for the year 1937.

_C. R. Ash_____, Teacher.

Not valid unless filled in and signed.
Not good if erasure made.

SCHOOL CHILDREN'S TICKET. Schoolchildren were admitted to the Washington County Fair, usually held in August, without charge during the Great Depression. The cost to enter was normally 5¢ per person. Ticket No. 19 was issued to Darrol Foster from Willisburg in 1937 and was signed by his teacher C. R. Ash. (Billy Cheser.)

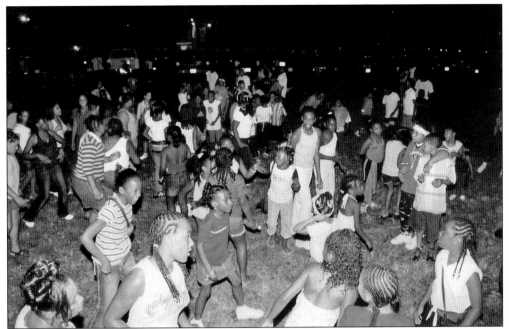

CHILDREN'S DANCE. At the Holy Rosary Annual Homecoming Picnic in 2000, a special time is set aside for the "children's dance," where kids can be kids, have fun, and dance as they please. The festive homecoming picnic grows each year, and in 2006 the City of Springfield joined the festival highlights with an African American Heritage celebration. The picnic offers traditional favorites, booths, and kid-friendly games. (Pamela Grundy.)

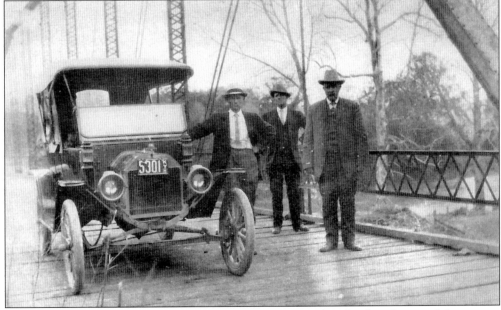

FREDERICKTOWN BRIDGE. Out for a drive in the country to show his friends around the county, Dr. E. L. McIntyre stopped his 1913 Model T Ford on the bridge. The car was one of the first three cars in Washington County. In this photograph from left to right are Dr. McIntyre and brothers John and James Wright, both visiting from Paris, Missouri. (Nick McWhorter.)

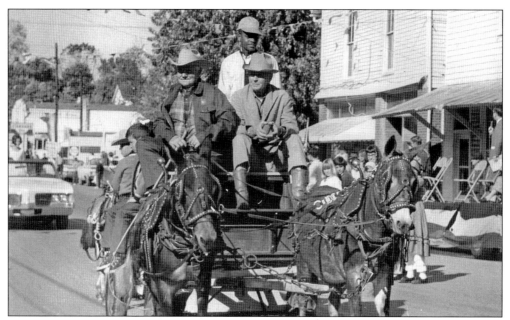

MACKVILLE PARADE. Famous for his mules and horses, Jack Arnold (left, holding the reins) is accompanied by his friends as they ride in the Mackville parade in the early 1950s on Main Street. Arnold was asked to bring his wagon and team to Frankfort in December 1975 for the inaugural parade in which Julian Carroll was sworn in as governor of Kentucky. (Billy and Bobby Cheser.)

PLAYING AT THE GROTTO. All over southern Washington County, stone grottoes honoring the Virgin Mary have been created in the yards of private residences. Seated in the backyard of the house of their mother, Mary Spalding, are Susan and Peter Spalding. Mary passed away May 4, 2007. (Pamela Grundy.)

DANCING THE WALTZ. Jane O'Bryan and Bobby Boone are seen here in the early 1950s at a St. Rose dance. St. Rose was the social cornerstone for dances, softball, organized trips, and gatherings of all kinds for the entire county. It offered a variety of events for young single Catholics. A lot of Washington County couples met at St. Rose and later married there. (Jane O'Bryan.)

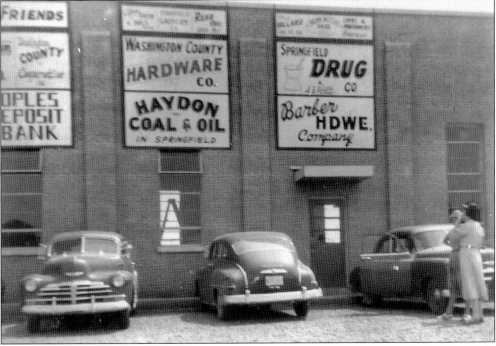

GOING TO THE GAME. Cars parked outside the gym wait for the game to start. Because Springfield was the largest city and center of commerce for Washington County, local businesses placed advertisements on the exterior of its old high school gymnasium, as pictured here in 1952. The three 1950s-era cars are parked below signs for Peoples Deposit Bank, Haydon Coal and Oil Company, Barber Hardware Company, Springfield Drug Company, and Washington County Hardware. (Jane O'Bryan.)

LEANING ON THE NEW CAR FOR A SMOKE. New cars were a luxury and had to be kept pristine—both outside and inside. Joe O'Bryan and Glenn Ewing have pulled this 1947 Chevy off a dirt road to enjoy a cigarette on a cold December afternoon. (Jane O'Bryan.)

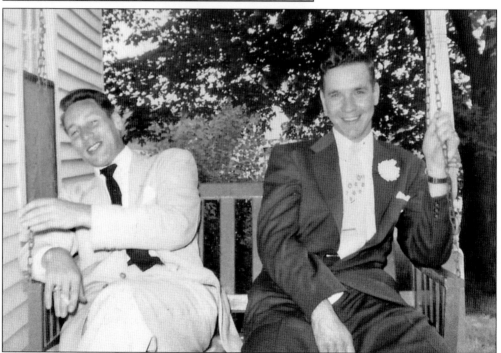

SWINGING. A joyful Joe O'Bryan sits in a swing with his cousin Will Hahn at the reception for his wedding to Jane Osbourn on May 15, 1954. (Jane O'Bryan.)

BEFORE AIR CONDITIONERS.
Joe O'Bryan and Glenn
Ewing, both in their twenties,
are getting ready to meet
their future spouses and to
take a swim for relief from
the heat of a Kentucky
August. (Jane O'Bryan.)

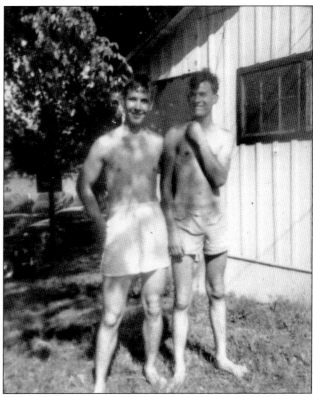

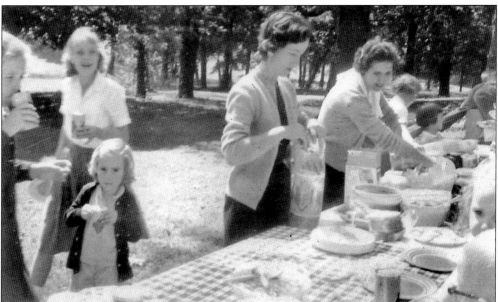

FAMILY REUNION. The O'Bryan family reunion in 1962 was like most family reunions in the mid-South. It was a summer, serve-yourself, potluck lunch in a local park, with baseball, a game of horseshoes, hugs, good conversation, and lots of fun topped off with a full glass of ice-cold tea. Putting out the food for a big family spread are, from left to right, Doris, Christine, and Nancy O'Bryan. (Jane O'Bryan.)

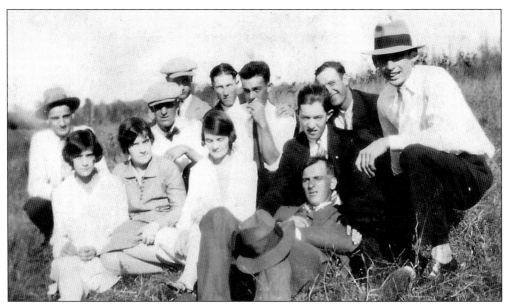

ST. ROSE TRIP. This may be a group of young Catholic singles assembled at St. Rose to depart on an outing and spend the day in Lexington in the late 1920s. Fourth from the left, wearing a dark suit and seated on the ground in the first row, is Thomas Smith. No one else in this picture could be identified. (Jane O'Bryan.)

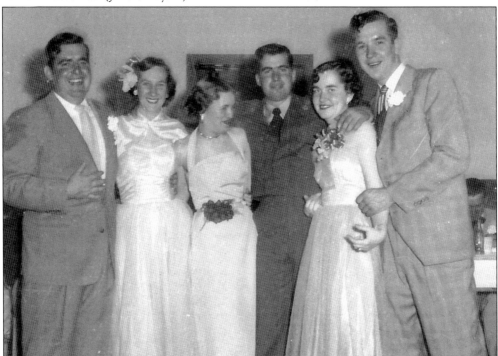

DANCE AT ST. ROSE. The center of social activity in the early 1950s, St. Rose held Catholic dances about four times a year. At these dressed-up affairs, evening gowns reminiscent of Hollywood movie stars were a "must have" for the ladies. From left to right are Sports Hamilton, Totsie Boone, Emma Osbourne, Nath O'Daniel, Jane Osbourn (O'Bryan) and Joe O'Bryan. (Jane O'Bryan.)

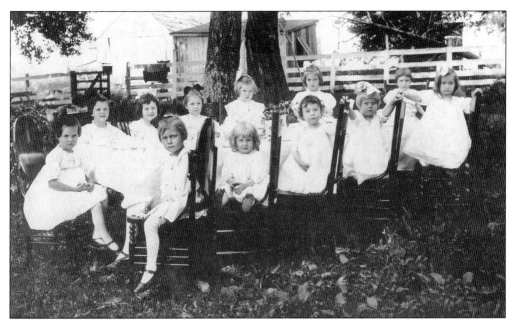

BIRTHDAY PARTY OF ANGELS. These little girls are at a birthday party outside for one of their friends in Mackville. Pictured from left to right are the following: (first row) Katherine Sterling, Mary Litrey Sterling, Juanita Raybourne, Sarah Sterling, and Margarite Rinehart; (second row) Julia Rinehart, Margaret S. Raybourne, Eva Casel, Ruby Shewmaker, Anna Cochran, Vergie Lee Riley, and Lela Shewmaker. (Helen and Kenneth Gabhart.)

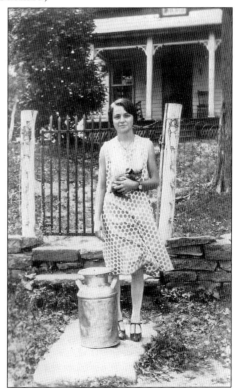

WAITING FOR THE MILKMAN. Sixteen-year-old Elizabeth Van Moore and her kitten are waiting on Route 422 and Poland Road for her boyfriend, Cecil Kays, who worked for the local milk company, to pick up the can full of milk and take it to the creamery in Springfield. Cecil and Elizabeth Van were married two years later. She is 93 today. (Billy and Betty Jane Cheser.)

POSTCARD STAMP. This 1¢ stamp, postmarked 1909, was sent on a short love letter squeezed onto a postcard addressed to Lanis Foster from Ora. (Billy and Betty Jane Cheser.)

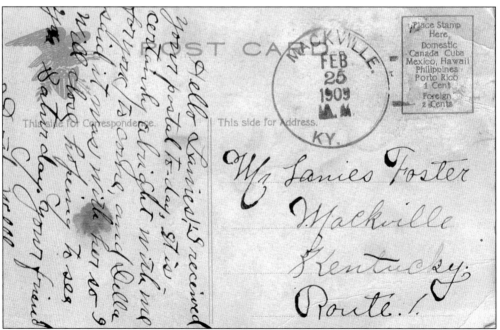

POSTCARD. There is nothing as sweet as receiving unexpected correspondence from a dear friend or love interest. This postcard addressed to Lanis Foster of Mackville is dated February 25, 1909. (Billy and Betty Jane Cheser.)

TWIN FLOATS. Bobby and Billie Cheser ride in the Willisburg parade in 1996. This parade had three "twin" floats with 30 sets of twins and one set of triplets riding. This was the first year the town held the Willisburg homecoming festival on Memorial Day, May 30. (Bobby and Mary Martha Cheser and Billy and Betty Jane Cheser.)

FAMILY PICNIC. In 1939, the Cooksey family stopped for a picnic. Seated from left to right are Betty Jane, Marjorie, Jodie, and Birchell Cooksey on Willisburg and Mackville Road. (Billy and Betty Jane Cheser.)

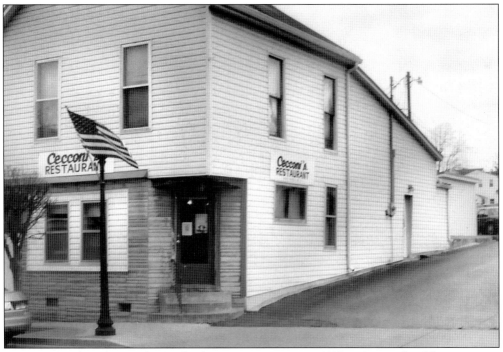

CECCONI'S RESTAURANT. This site has been a restaurant since 1937, making it the oldest operating restaurant in Springfield and in Washington County. Named for Joe Cecconi, father of Mayor John Cecconi, the restaurant still has an old-time lunch counter. The restaurant was once owned by Tom Harmon, who died in 2007 at 106 years old. Vhonda Barlow and Debbie Seng, owners since 1992, sell their mother's pies. Edna Seng uses old family recipes in her cooking.

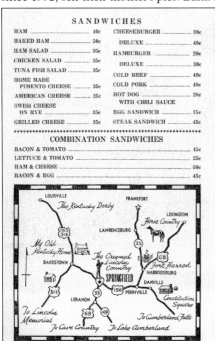

SANDWICHES

HAM	40c	CHEESEBURGER	30c
BAKED HAM	50c	DELUXE	40c
HAM SALAD	35c	HAMBURGER	20c
CHICKEN SALAD	35c	DELUXE	30c
TUNA FISH SALAD	35c	COLD BEEF	40c
HOME MADE PIMENTO CHEESE	35c	COLD PORK	40c
AMERICAN CHEESE	25c	HOT DOG	20c
SWISS CHEESE ON RYE	35c	WITH CHILI SAUCE	
		EGG SANDWICH	15c
GRILLED CHEESE	35c	STEAK SANDWICH	45c

COMBINATION SANDWICHES

BACON & TOMATO	45c
LETTUCE & TOMATO	25c
HAM & CHEESE	50c
BACON & EGG	45c

EGG SANDWICH, 15¢. This 1950s menu is from Bosley's Restaurant, later to become Tom's place and finally Cecconi's restaurant in Springfield. It is still the longest and oldest operating restaurant in Washington County. Gone are the days when a cheeseburger cost 30¢. Below is a map of local highlights of the areas surrounding Springfield. The "Coffee Ladies" club still meets at the restaurant almost every day. (Bobby Cheser.)

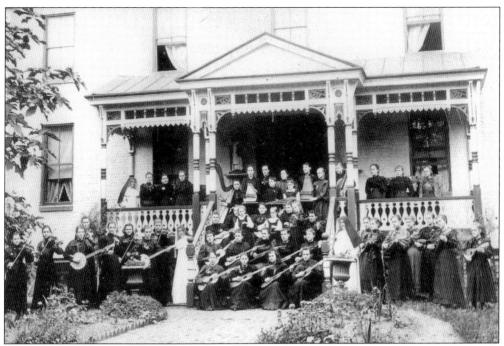

MAKING MUSIC TOGETHER. The music class at St. Catharine Academy plays together in 1906. The three Dominican sisters that taught the class pose with the girls. (Sr. Rosemary Cina and St. Catharine Motherhouse.)

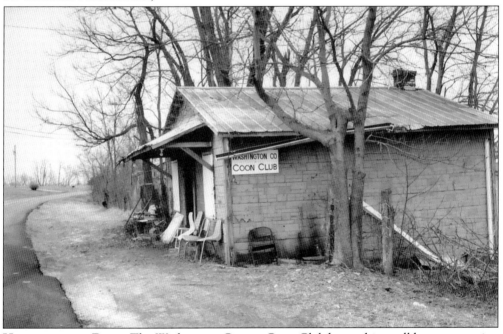

HUNTING WITH DOGS. The Washington County Coon Club keeps this small hut as a meeting place before a hunt. Raccoon hunters from in and around the county meet here with their dogs periodically. The dogs tree the raccoon, and the hunters locate the dogs by the baying sound that they make.

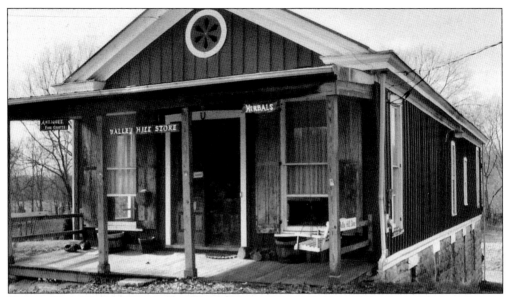

VALLEY HILL STORE. Stopping by to browse for antiques and chat with Rosemary Bailey, an artist and poet, was a real treat. She retired in 2006, and now the antique shop stands empty. In 1888, the little train depot, post office, and general store were built to serve the railroad spur line that ran from Louisville to Springfield.

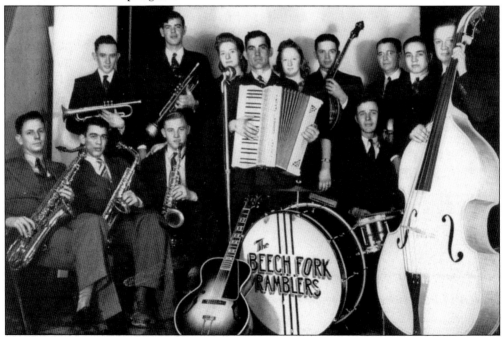

THE BEECH FORK RAMBLERS. Popular at social events, dances, and weddings all over the county, the Beech Fork Ramblers were a wonderfully talented band formed in Fredericktown. Pictured from left to right are the following: (first row) J. P. Willett (saxophone), Frank Taylor (saxophone), Jimmy Nally (saxophone), and Hilman Taylor (drums); (second row) Charlie Wathem (trumpet), Mutt Lanham (trumpet), Bea Mudd, S. T. Hamilton (accordion), Margorie Wathen, Gene Taylor (banjo), Chester Taylor, Frederick Nally, and Paul Wathen (cello). (Joyce and Buddy Taylor.)

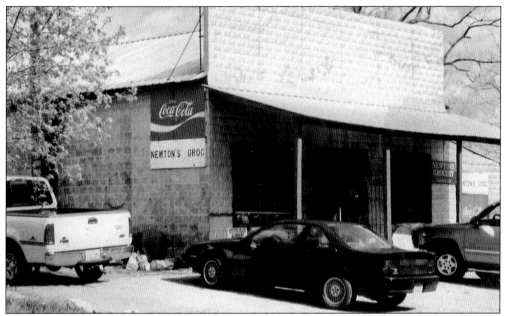

THE NEWTON COUNTRY STORE. One of life's simple pleasures is slowing down and visiting the only remaining country store in Washington County. This country store, located in Manton, is extremely popular with the locals as a place to meet and play cards. It was built in 1925 and still has a pot-bellied stove inside for heat in the winter and a sign that reads, "Welcome to Blincoe," which was later renamed Manton. It is operated by the Newton brothers. (PNG.)

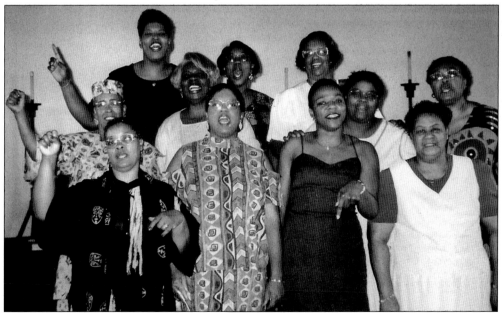

LIFTING VOICES TO THE LORD. The Holy Rosary gospel choir sings "Amazing Grace" as they lift their voices up to the Lord. Pictured from left to right are the following: (first row) Pamela Grundy, Angela Linton, Mary Mitchell, and Frances Fogle; (second row) Deloise Logan, Jo Ann Cooper, Jo Ann Ellery, and May Spalding; (third row) Jackie Cooper, Anita Spaulding, and Georgie Montgomery. (Pamela Grundy.)

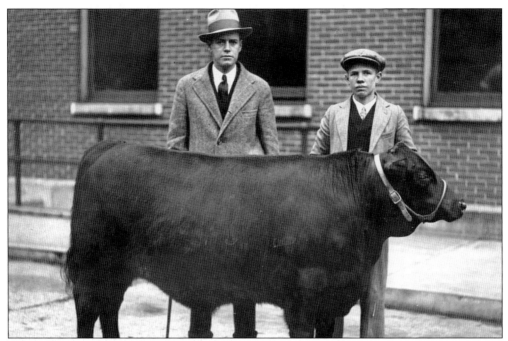

WINNING WITH A GRAND CHAMPION. Albert Ward (right) of Washington County with his grand champion calf at the last 4-H Fat Cattle Show. G. W. Gardener, at the left, was the county extension agent. The calf sold for 45¢ per pound after the show, weighing in at 820 pounds. The champion calf also won $145 in premiums and a trip to the International Livestock Show in Chicago. The Angus was brought from J. Harry Allen, a breeder in Lexington. (Kentucky History Center.)

A LITTLE GIRL'S SMILE. Mary Jane Tuten, nine and half months old, sits curbside in a new outfit in Springfield. Sidewalks and dressed curbs were completed in Springfield in 1902. (Joyce Taylor.)

NEW BIKE. Patricia Jean Osbourn, 16 years old, is riding her new birthday bike down the gravel driveway in the backyard of her parents' home. Like most people unfamiliar with a new bike, she soon hit the fence and fell off. (Patricia Ewing.)

LEAVING FOR THE HONEYMOON. Regina Osbourn, daughter of Victor Osbourn, is shown here newly married to Thomas Proffit. Married on April 14, 1945, they left for their honeymoon in this 1937 Ford. Jack Osbourn was the ring bearer at the ceremony. Regina, who was deaf, was skilled at lip reading and sign language. (Joyce Taylor.)

SHARING LUNCH. This unidentified little girl from Springfield appears unaware that she is sharing her picnic lunch with a hungry kitten, which happily steals from her sandwich. (Joyce Taylor.)

WATCHING THE TRAFFIC. Jane Cambron is seated on the steps outside of the Osbourn home on Lebanon Road. She is passing time watching folks walk by on the road. She later married into the Luckett family and moved to Louisville, where she sold real estate. (Joyce Taylor.)

"Push Me, Please." Laura Marie and Marty Smith (seated in the wagon) are playing in a wagon on Bearwallow Road. Shortly after taking her vows as a nun at the age of 22, Sr. Laura Marie Smith died from nephritis on April 4, 1956. (Joyce Taylor.)

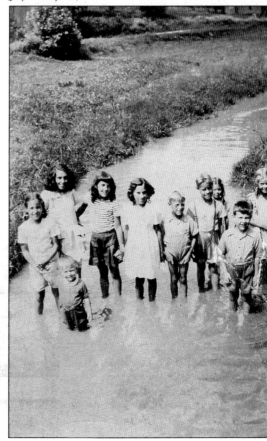

Playing in the Creek. During the lazy days of summer, nothing relieves the heat better than playing in the creek for hours while catching crawdads and minnows with the neighborhood kids and families. This picture was taken in Texas, Kentucky, on the farm of Zin and Ammy "Ella" Pope Kimberling on Long Run Road in the late 1930s. (Larry Randolph.)

WISHING WE COULD DRIVE DAD'S CAR.
Sitting in their father's Model T and too young
to drive are George Lloyd Haydon (inside the
car) and Halley Haydon (sitting on the running
board). (Mary Barber.)

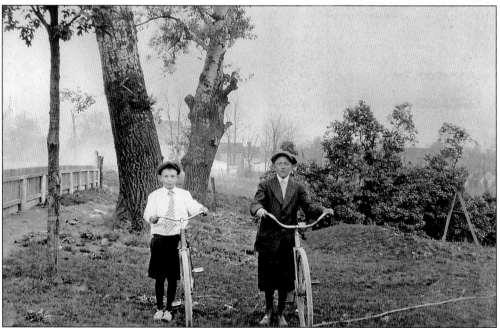

RIDING BIKES. George Lloyd Haydon and his young friend are riding in downtown Springfield,
where the roads were a little better for biking in 1912. (Mary Barber.)

GRADUATION. Nora Clements is a young graduate from St. Catharine Academy in Springfield in 1875. She is wearing the white dress and headdress traditionally worn at the academy for graduation ceremonies. The graduation certificate is hand lettered and printed on a canvas cloth, about 3 feet by 3 feet. (Sr. Rosemary Cina and the St. Catharine Motherhouse.)

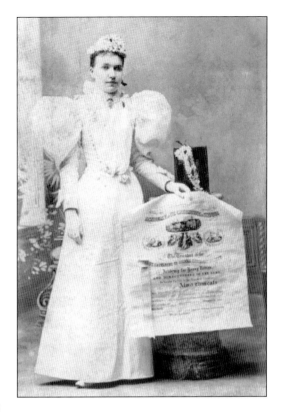

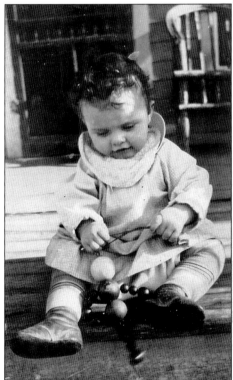

CHILD'S PLAY. Playing with her toy, this child seems to be mesmerized. This is one of Frank McWhorter's favorite pictures of his little girl, Emma Merrilynn, at one year old. He affectionately called her "Daddy's dirty baby," as she was always getting into something or wearing a few smudges from playing outside. (Nick McWhorter.)

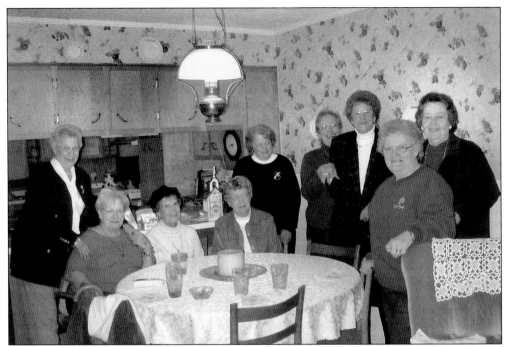

FRIENDS FOR OVER 40 YEARS. The Washington County Town and Country Homemakers are pictured here at Dorothy Buckler's house on East Grundy Avenue in Springfield. From left to right, they are Joyce Reddick, Dorothy Buckler, Cloteal Funk, Lorraine McMurtry, Ella Mae Davis, Martha Ann Haydon, Violet Elliott, Reba Hamilton, and Ann Faye Sallee. (Dorothy Buckler.)

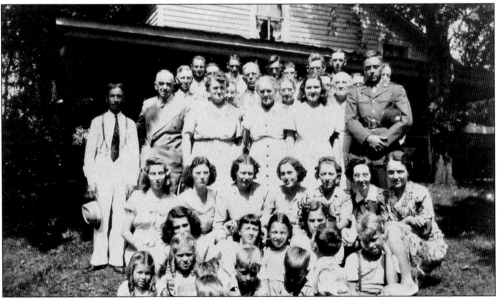

FEELING WANTED AND LOVED. Charles Nathaniel Rogers, son of Jonas Paulin Rogers and Myrtle Grove Pope-Rogers, is seen here home on leave from World War II. The entire family, happy to see him, held a family reunion in his honor on Shortline Drive in Texas. Charles is the great-great-grandson of John Pope, a well-known statesman whose house is designated in Springfield by a state historic marker. (Larry Randolph.)

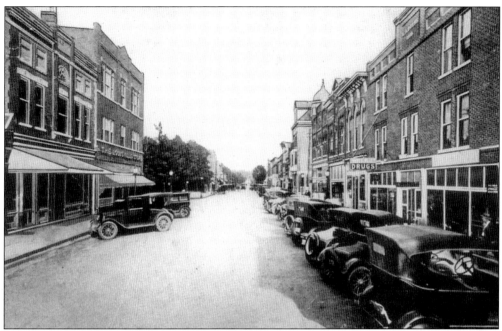

DOWNTOWN SPRINGFIELD. This long view down Main Street captures life in Springfield in 1925. Clearly visible on the right-hand side of the photograph is the Springfield drugstore. During the 1920s, Springfield was a place of excitement and intrigue. The place to trade your goods and buy a new dress was Cunningham's, Robertson's, Inc., or the Louisville store (on the left side of the picture). (Nick McWhorter.)

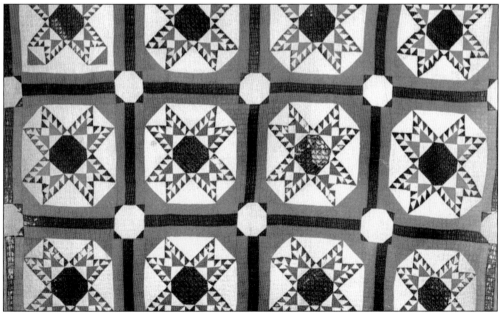

FOX TWINKLING STAR QUILT. This unique quilt was quilted by Bea Fox, then a girl of only 13 and a student at St. Catharine Academy in Springfield. Later she married John Fogary; both were natives of Boyle County. She was the daughter of Mr. and Mrs. William Fox, who came from Limerick, Ireland, in 1849. (Kentucky History Center.)

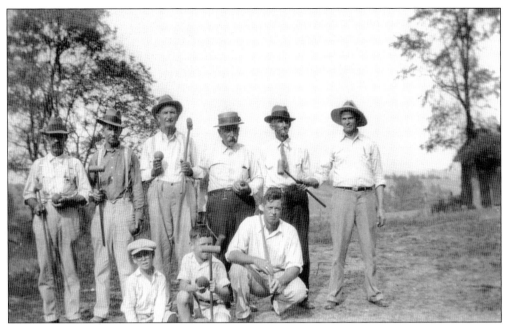

A Game of Croquet. These Washington County men and their sons are enjoying a relaxing game of croquet. Each holds a croquet ball and mallet, sometime in the late 1920s. (Bob Bottom.)

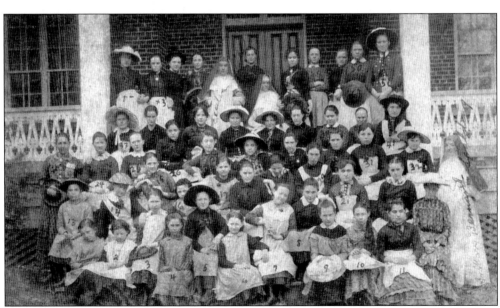

Going to School. This group of young friends, pictured in 1885, went to school together every day for 12 years. During that era, going to school in Kentucky past the eighth grade and going to school at St. Catharine Academy were considered privileges. (Sr. Rosemary Cina and St. Catharine Motherhouse.)

DRESSING UP. This beautiful young girl from Springfield is unidentified. She poses for a picture with a lace-trimmed shawl, new dress, and both a ladies' sun umbrella and a fan. Her hair is in ringlets, popular in the late 1890s. (Nick McWhorter.)

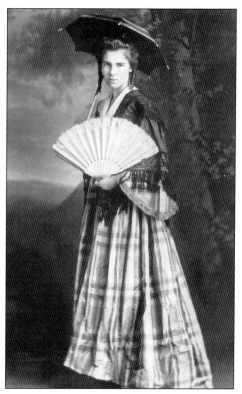

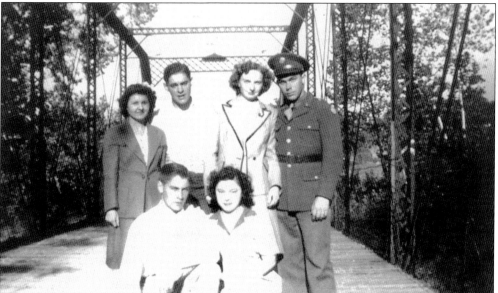

BOOKER ROAD IRON BRIDGE. Pictured here from left to right in 1943 are the following: (first row) Ed Mattingly and his sister Rose; (second row) Dorothy and Joseph Mattingly with Mary Elizabeth Abell (fiancée of Richard) and Richard Mattingly (in his U.S. Army uniform). The photograph was taken just before Richard left for his tour of duty in Europe during World War II. The iron bridge where this picture was taken was torn down in the 1970s and replaced with a concrete bridge. (Laurie Smith.)

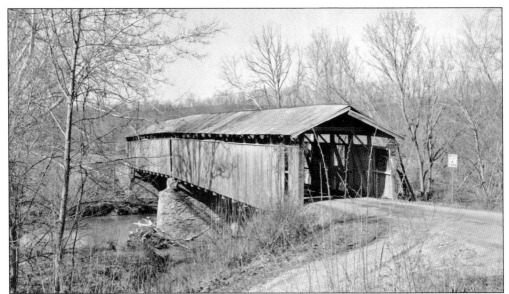

THE LAST ONE STANDING. The Mount Zion Bridge is only one of 14 existing covered bridges in Kentucky. Also known as the Beech Fork River Bridge, it sits off of Kentucky Highway 458. The bridge is the longest multi-span bridge in the state at 211 feet long. Although the bridge is closed to automobile traffic, many still visit it. Richard Hamilton structurally reinforced the bridge at his own expense. (Kentucky History Center.)

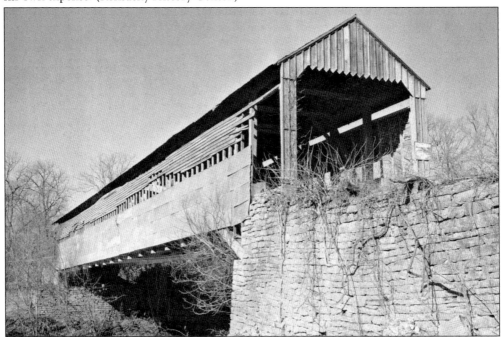

ONE OF THREE. At one time, three covered bridges were located in Washington County. This bridge spanned the Chaplin River at Sharpsville. The construction of this bridge was authorized in 1853, and Stephen Stone and his sons completed construction and opened the bridge to traffic in 1857. This bridge fell in on itself on June 23, 1973. The photograph was taken by L. E. Vaughn on February 15, 1965, for the U.S. Department of Highways. (Kentucky History Center.)

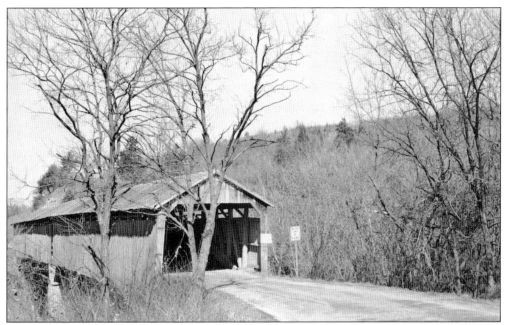

COVERED BRIDGE. In the early 1800s, there were over 400 covered bridges in Kentucky, carrying foot, horse-and-buggy, and later automobile traffic. Located at the Washington and Nelson County Line on Kentucky Highway 578, this historic covered bridge was washed away in a flood. Many of the bridges in Kentucky were lost due to arson, neglect, or replacement by modern metal bridges. (Kentucky History Center.)

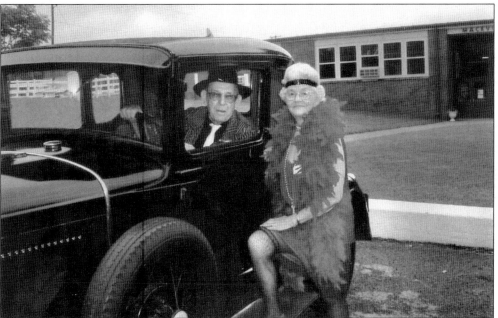

PUTTIN' ON THE RITZ. Over 100 couples attended the Puttin' on the Ritz lunch depicting the Roaring Twenties in Mackville. Married for 61 years, Kenneth and Helen Gabhart are enjoying a vintage ride in a Model A Ford outside the Mackville High School Community Center in 2004. Helen Gabhart won the best-dressed competition. (Helen and Kenneth Gabhart.)

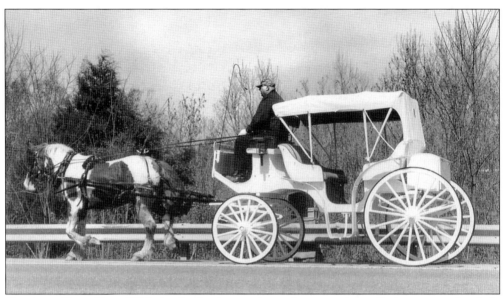

CARRIAGE RIDE. One of life's simple pleasures is a horse-drawn carriage ride downtown after dark. Danny Yaste is traveling down Highway 555 along the shoulder of the road heading to Springfield on Friday afternoon. He provides tours around Springfield's city limits and is popular with the locals, especially after a dinner date at Mordecai's restaurant.

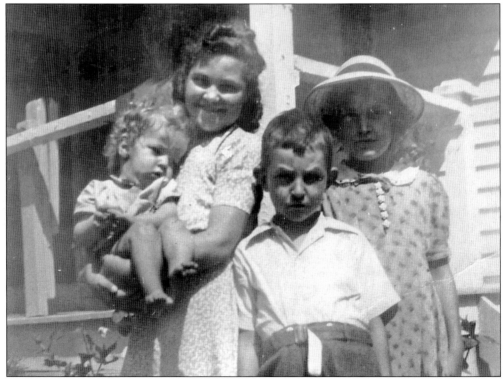

TAKING CARE OF EACH OTHER. Joyce Osbourn holds her baby sister, Elizabeth Louise "Betsy Lou," because she is unable to stand on her own. Jane Osbourn, wearing a hat, stands beside her sisters and her brother Leo. (Joyce Taylor.)

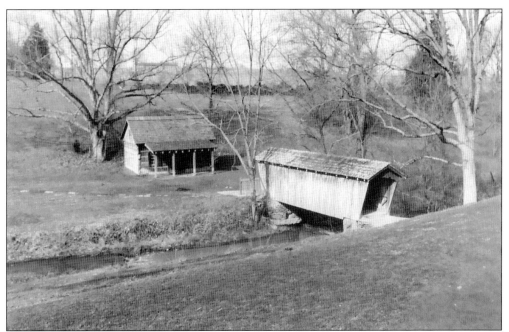

LIVING WITH HISTORY. Tourists from around the United States have visited the Lincoln Homestead State Park. The blacksmith and carpenter shops, built in the style of log homes, are where it is thought that Thomas Lincoln learned the craft of cabinetmaking from Richard and Francis Berry.

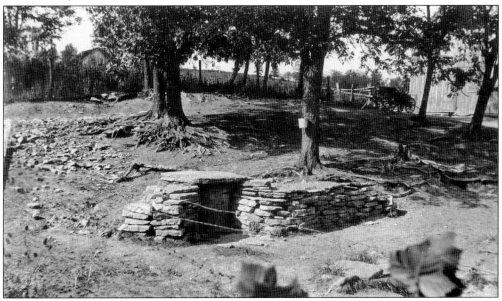

THE SOUND OF LINCOLN SPRINGS. Located five miles north of Springfield, the Lincoln Homestead Park is a repository of Lincoln history and the site of this natural spring. The trees, barns, and barbed wire seen in this early picture have all been removed for a more pristine "park" look. The park spans 120 acres and contains a golf course. This site in Washington County is widely known as the spot where Thomas Lincoln and Nancy Hanks, the parents of Pres. Abraham Lincoln, were married in 1806. (Kentucky History Center.)

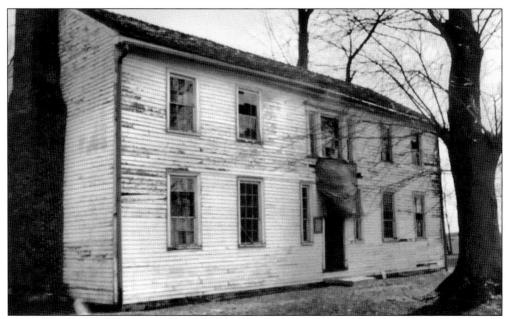

KEEPING HISTORY ALIVE. Mordecai Lincoln was Abraham Lincoln's uncle. He brought down the Native American that killed his father. His action also spared the life of his brother Thomas—and that of the future father of our 16th president. The Mordecai Lincoln house is the only known structure owned and occupied by a member of the Lincoln family still located on its original site in Kentucky. The Commonwealth of Kentucky funded its preservation in 2006 at a cost of about $800,000.

SMALL-TOWN GIRLS VENTURE TO THE BIG CITY. Mary Smith Osbourn (behind the sign) and her two friends left Springfield for a day along the river in Louisville. Louisville has always been the "big city" destination for Washington Countians because of its proximity and road access. About an hour away, Louisville is a major source of employment for the county. (Joyce Taylor.)

Two

EDUCATION
AND RELIGION

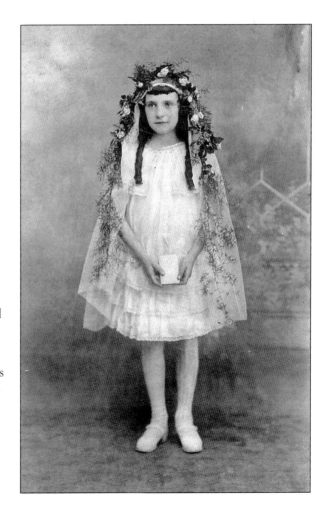

FIRST COMMUNICANT. Postmarked in 1923, this unidentified little girl is holding a traditional white prayer book given as a gift to First Communicants. Her hair in ringlets under a veil heavily decorated with fresh flowers and greenery, she wears her First Communion gown. A common practice of the time, postcards were often sent depicting significant family events, as they were more affordable and durable than photographs. (Joyce Taylor.)

REVIVAL. R. T. Hickerson, an evangelist and traveling preacher, was well-known throughout Washington County's Christian community. In 1936, people came from all over to hear him speak over the course of two weeks at the Mackville Christian Church. The church was filled to capacity, so people would stand outside beneath the windows to hear him. People traveled for miles on horseback or by buggy to the revival. (Helen and Kenneth Gabhart.)

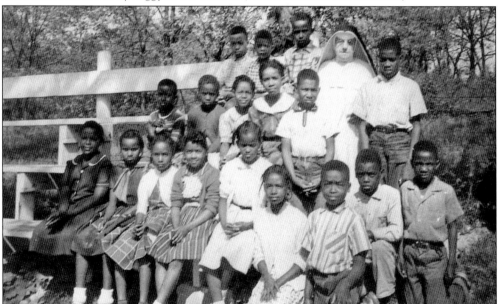

HOLY ROSARY CLASS PHOTOGRAPH. This is a 1950s class photograph of Holy Rosary Catholic Church students. Taught by the Dominican nuns of St. Catharine Motherhouse, these children, from left to right, are the following: (first row) Lilly Mudd, Ella Johnson, unidentified, Rita Wright, Mary Bennett Walker, Margaret "Tootsie" Ellery, Andy Spalding, unidentified, and Garfield Jones; (second row) two unidentified students, Betty Edelen, Virginia Edelen, Donnie Weathers; (third row) unidentified, Jody Barber, Johnnie Gerton, an unidentified Dominican nun, and Charles Spalding. (Pamela Grundy.)

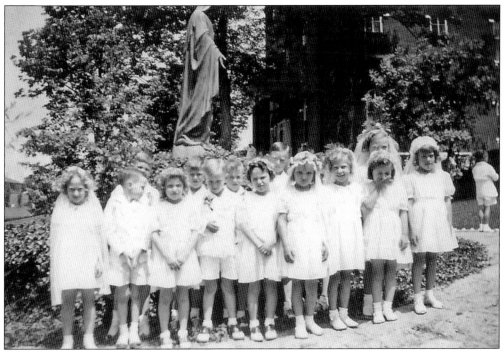

FIRST COMMUNION. Joyce Osbourn is pictured with her second-grade class at St. Rose Catholic Church in 1941. A statue of the Virgin Mary stands behind the children. On the first row fifth from the left is Joyce Taylor. (Joyce Taylor.)

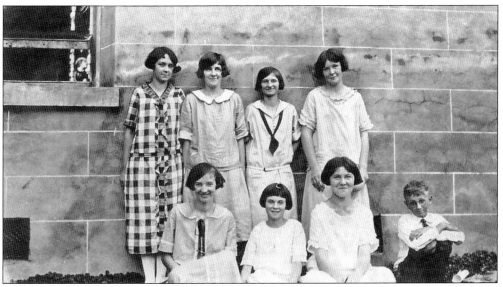

WATCHED OVER BY ST. ROSE. This high school class photograph was taken outside of St. Rose Church in 1926. In the first row Jane Mattingly (left) is sitting next to her friends. In the second row, second from the left is Mary Angela Osbourn. The little boy with glasses has made his way reluctantly into the outskirts of the picture, even though he knows he's not one of the girls' club. A picture of St. Rose of Lima is sitting in the window. (Joyce Taylor.)

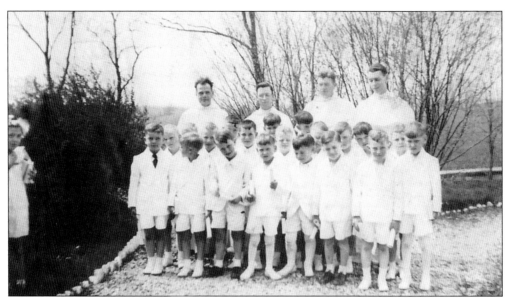

BOYS-ONLY PHOTOGRAPH. Standing fourth from the left in the second row is James Leo Osbourn. His second-grade class made a boys-only photograph of their First Communion at St. Rose School in 1938. Standing behind the communicants are some of the brothers "in training" at St. Rose Priory. Leo Osbourn died in 1976 as the result of a sawmill accident in Washington County. He left six children behind; the youngest was six years old. (Joyce Taylor.)

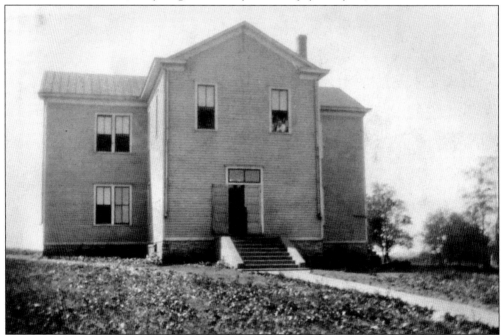

MACKVILLE SCHOOL. Mackville School, pictured here in 1920, consisted of 90 students and housed grades 1 through 12. There were two stairwells in the school. Principal Otho Gaffin (served 1928–1941) created a stage with folding doors on the top floor. There was also an enclosed spiral slide fire escape. The Mackville High School was later converted into a community center, which continues to be a focal point for the community. (Helen and Kenneth Gabhart.)

44

MACKVILLE COMMENCEMENT. This announcement for the Mackville School commencement service is dated 1932. Prior to the commencement, seniors enjoyed class night, where they willed something to each classmate and predicted their futures. Women were commonly given a rolling pin to symbolize marriage and housekeeping. The baccalaureate service was a sermon at the church, and commencement was the presentation of the high school certificate. (Helen and Kenneth Gabhart.)

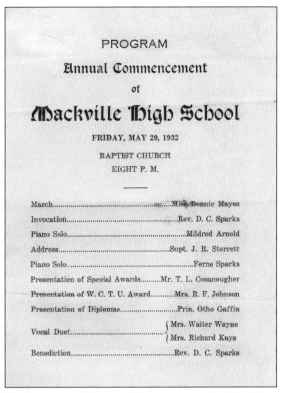

PROGRAM

Annual Commencement

of

Mackville High School

FRIDAY, MAY 20, 1932

BAPTIST CHURCH

EIGHT P. M.

March	Miss Bonnie Mayes
Invocation	Rev. D. C. Sparks
Piano Solo	Mildred Arnold
Address	Supt. J. R. Sterrett
Piano Solo	Ferne Sparks
Presentation of Special Awards	Mr. T. L. Cocanougher
Presentation of W. C. T. U. Award	Mrs. R. F. Johnson
Presentation of Diplomas	Prin. Otho Gaffin
Vocal Duet	{ Mrs. Walter Wayne / Mrs. Richard Kays
Benediction	Rev. D. C. Sparks

TERAH TEMPLIN. This small, one-room stone house is 200 years old and is still as sturdy and straight as the day it was built. Built with rustic windows (no glass), its stone walls are over 2½-feet thick. Templin was the first ordained minister in Kentucky of the Presbyterian faith. He often held prayer services from inside the walls of this home for the people of Washington County.

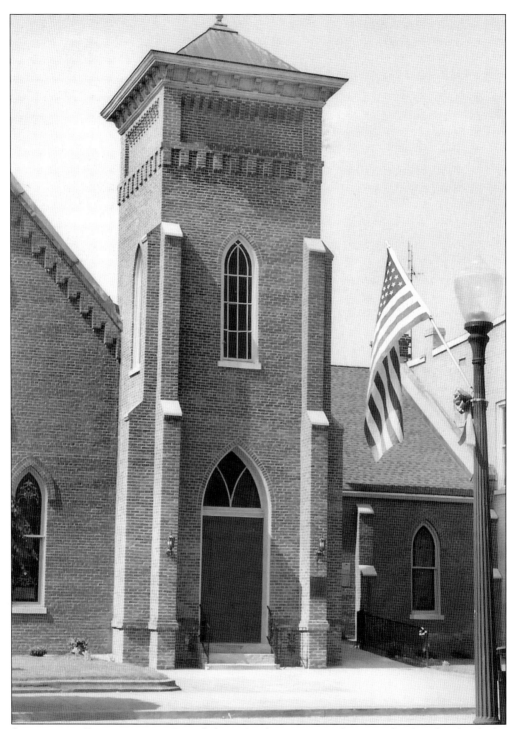

SPRINGFIELD PRESBYTERIAN. Founded in 1788 by emigrants from Scotland and Ireland, the beginnings of this church are closely associated with the pioneer missionary work of the Reverend Terah Templin. After a fire in 1888, the present church was built in brick and connected to the bell tower, which had to be lowered 30 feet for safety.

46

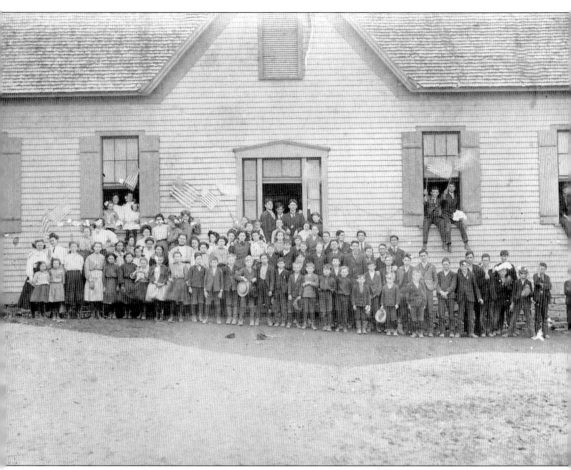

HANGING OUT OF THE WINDOWS. This 1909 photograph of the Mackville School was taken on Armistice Day. Pictured from left to right are the following: (first row) Mae Arnold, Catherine Isham, Janie Baker, Ovia Cunningham, Grace Cull, Pearl Shewmaker, Frances Haydon, Ada Campbell, Mattie Lowber, Maurice Wycoff, Jim Hilton, Elb Baker, Walker Keightly, Armond Britton, Buell Webb, Ray Bottom, Herman Darnell, Spenser Simpson, Richard Kays, Worley Baker, George Lowber, Otha Keightly, and Jim Lowber; (second row) Annabelle Riley, Ora Kate Bottom, Bessie Wright, Lettie Mae Kays, Ovie Britton, Betty Mae Haydon, Johnny Peters, Bill Hilton, Harry Raybourne, McDonald Darnell, Minor Bottom, Coleman Campbell, Albert Crawford, Fred Mayes, Lanis Foster, Hartford Matherly, Tommy Hickerson, Gilvie Bottom, Ray Lowber, Raymond Turner, Joe Latimer Wycoff, Broy Wright, Less Hilton, George Yancey, Homer Yancey, Coleman Wright, and Joe Davis; (third row, standing) Elizabeth Isham, Beulah Turner, Beulah Shewmaker, Hallie Whitehouse, Maggie Mae Wycoff, Pearl Hickerson, Mattie Keightly, Cordie Whitehouse, Bessie Sweeney, Katie Lee Arnold, Laura Keightly, August Shewmaker, Mae Hamilton, Margie Shewmaker, Gertie Isham, Nora Baker, Harvey Sweeney, Ernest Hume, Charlie B. Bottom, and Berkeley Campbell. Sitting in the second window from the left are Catharine Hamilton, Briggs Wycoff, Nannie Lou Hilton, and unidentified; under the door sash are principal Walter Matherly and teachers Walter Hume and Elmer Hume. Sitting in the third window from the left are Jim Peters and Omer Hume (both holding flags). In the fourth window from the left are Lloyd Walker and Bill Graves. (Helen Gabhart and Bill Graves.)

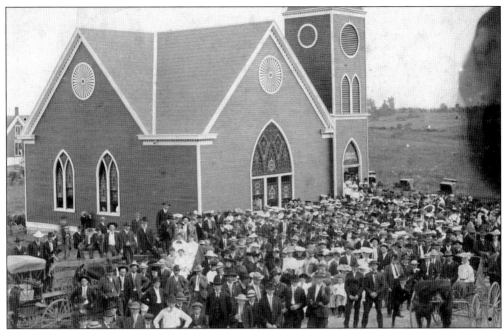

MACKVILLE CHRISTIAN CHURCH. People came from far and wide, by horse and buggy, by foot and on horseback to participate in this stirring 1905 revival. The church and its congregation stood as beacons for spiritual growth and as a testament to the importance that religion played in the social activities of the community during that period. (Helen and Kenneth Gabhart.)

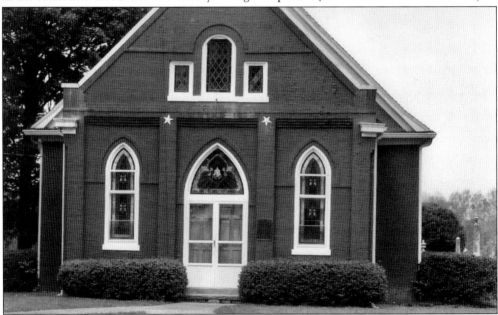

PLEASANT GROVE PRESBYTERIAN CHURCH. This tranquil church, located on Pleasant Grove Loop, was founded by Stephen Cock Brown in 1833. Marshall Young, a local furniture maker, made the simple cross above the altar from a 34-year-old tier rail taken from Taylor Spaulding's tobacco barn. In 1974, Ernest Shewmaker, of Poorville, converted them into the cross that hangs above the church altar. Twenty families attend services in this historic church today. (Taylor Spaulding.)

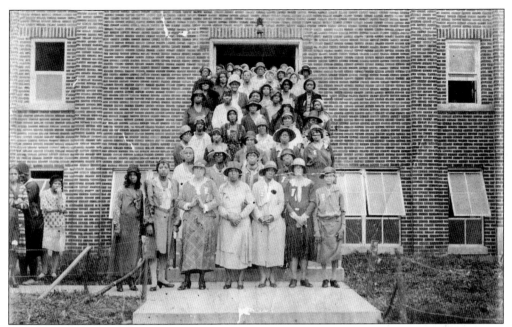

ALTAR SOCIETY. In 1940, the altar society of Holy Rosary Church poses at the church. First row, fifth from the left are Rosella Mudd, Liza Burnett, and Mamae Hamilton. In the third row, starting third from the left, are Josie Young, Mary Rose O'Banna, and Liza Davidson. In the fourth row, far left is Lizzie Wakefield. In the eighth row, fourth from the left are Kate Elliot and Katie Edelen. In the ninth row, the fourth from the left is Mary Edelen. (Bettie Walker.)

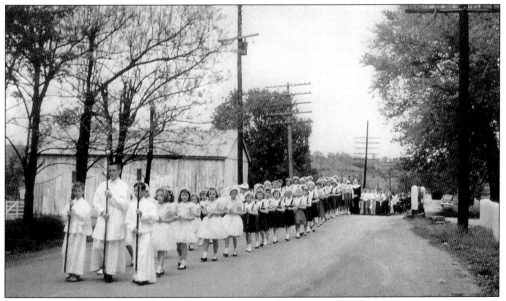

MAY PROCESSION AT THE "BURG." These First Communicants (in white) are led by the parish priest and altar boys and are followed by the children that attend Holy Trinity Catholic School and finally the parishioners. Children were taught by the Ursaline sisters. (Louise Nally.)

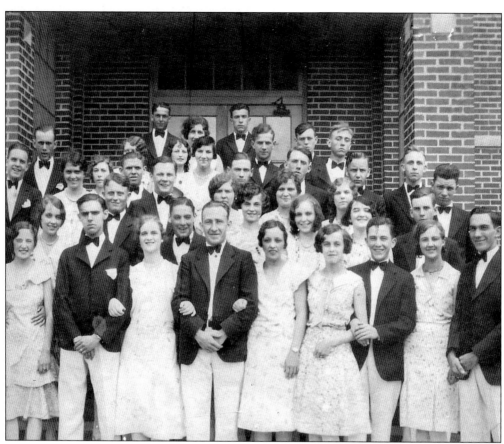

GRAPHICS. This photograph of the 1930 graduates of Springfield High School shows, from left to right, the following: (first row) Dave Thompson, Emma Joyce James, David Shapiro, Dorothy Campbell, J. W. Janes, Lucy Hertlein, Mary Wells, Robert Morris, Mary Fran Claybrooke, and T. F. Montgomery; (second row) Will F. Simms, Evelyn Rogers, J. B. Hagan, Bill Polin, Margaret Blandford, Elizabeth Orten, Catherine Settles, and James Reed; (third row) Robert Bateman, Zerelda Lake, Margaret Pope Gordon, James A. Walker, Oscar Boldrick, Alice Thompson, Irene VanDyke, James Grider, Alice Rudd, Beulah Shewmaker, Margaret James, James Gillespie, Dan Wimsatt, Aaron Nally, and George Wharton; (fourth row) L. A. Hamilton, Elizabeth Mattingly, James Wells, Edwin Jefferies, Joe Kelly, and Henry Pope. (Larry Randolph.)

THE FIRST HOLY TRINITY CATHOLIC CHURCH. The first Catholic church in Fredericktown was built in 1883. The first pastor, Fr. William M. Buckman, served the community for 18 years. Fredericktown is one of the oldest settlements in Washington County and is located halfway between Springfield and Bardstown. Before the church was built, the community was served by a circuit of traveling priests that went from one community to another giving out the sacraments and saying mass. (Louise Nally.)

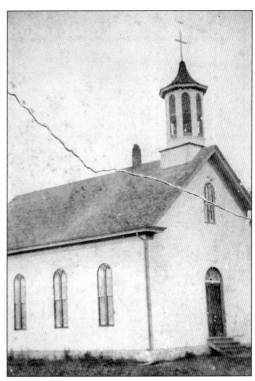

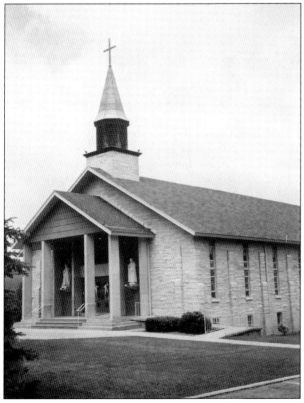

A NEW CHURCH. In 1955, a new Bedford stone church and rectory were built to accommodate the growth of the Holy Trinity Parish. Sam Nally, Everett Mudd, Richard Hamilton, William O'Daniel, Borgia Mudd, Paul Hamilton, and Robert Hamilton formed a committee to build the new church. Holy Trinity has become famous for its turkey social, serving over 2,500 meals. (Louise Nally.)

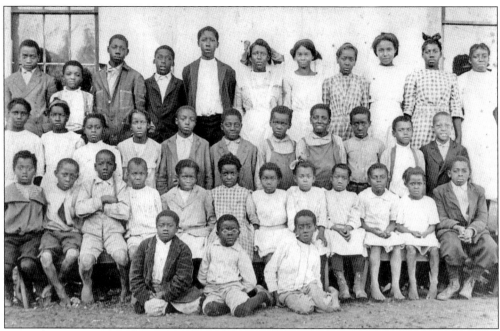

HOLY ROSARY'S SCHOOL PHOTOGRAPH. This *c.* 1900 class photograph shows children from the first through eighth grades at Holy Rosary Catholic Church. Only two decades away from slavery, these children came from modest means. Their grandparents were former slaves. Most of the children cannot be identified. In the second row, ninth from the left, is Burton Ellery; in the top row, seventh from the left, is Edwina Hamilton. (Pamela Grundy.)

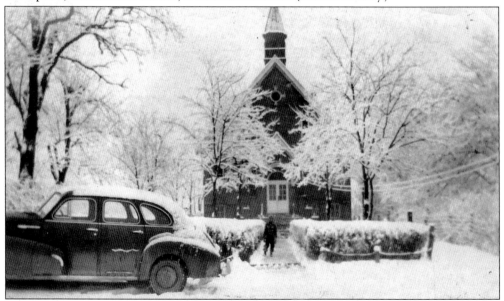

SNOWY SUNDAY. A lone parishioner has locked the church after mass and is heading back to his car, which is parked in front of Holy Rosary Catholic Church on a cold snowy Sunday in January. Affectionately called the Briartown Cathedral by its longtime parishioners, the church continues to grow. Additions to the church, church offices, and blacktop driveways have all been added since this 1940s photograph. (Pamela Grundy.)

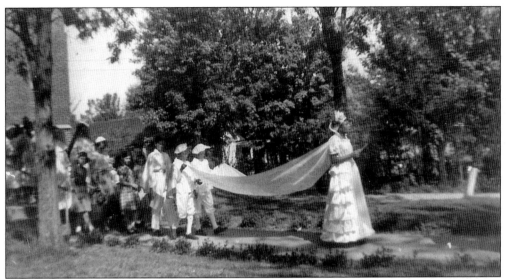

MAY PROCESSION. The children of Holy Rosary Catholic Church form a May procession in 1939 outside Holy Rosary Catholic Church. One girl is dressed up as the Virgin Mary (in the long veil), and the other children carry flowers in a parade behind her and file into the church during the mass sometime in May. Every little girl hoped she would be chosen to play the role of Mary. The next coveted place was to be picked to crown the statue of Mary with flowers. (Pamela Grundy.)

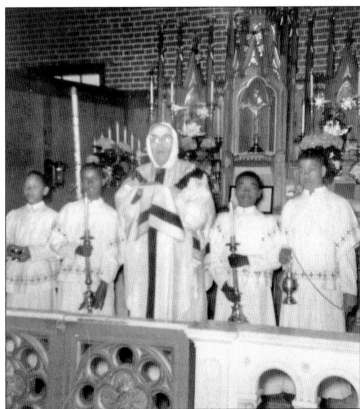

GIVING THE BLESSING. Father Bernard is shown here on the altar offering a blessing after saying the mass, assisted by altar boys (left to right) Larry Tucker, John Gerton, Andy Spaulding, and Bill Wakefield (holding incense). (Pamela Grundy.)

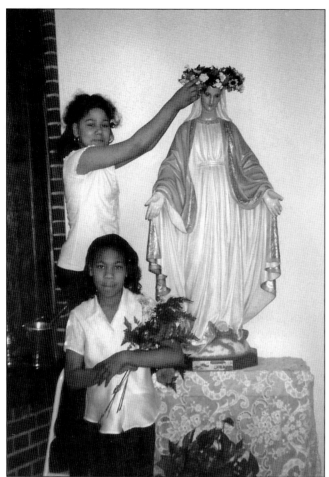

MAY CROWNING. During the month of May, traditionally reserved in the Catholic Church to honor the Virgin Mary, schoolchildren fashion a crown of flowers to adorn the head of the Virgin. Jessica Edelen is crowning Mary, and Cesalee Gerton is holding a bouquet of flowers to be placed in a vase at the foot of the statue. (Pamela Grundy.)

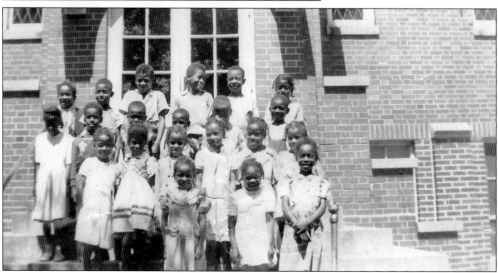

SMILE EVERYONE! The 1945 first-grade class smiles for the photographer on the steps of Holy Rosary Catholic Church. (Pamela Grundy.)

54

CHURCH BURNED BY ARSONISTS.
The first African American church in Washington County was built in 1930 and was later burned to the ground by arsonists. Pictured here is the hollow shell of the church. It was never proven, but the fire is suspected to be the work of the Klu Klux Klan, which was active in the county at the time. Undaunted, the parishioners of Holy Rosary Catholic Church later rebuilt on the same site. (Pamela Grundy.)

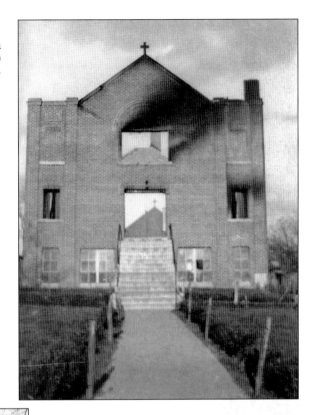

ST. DOMINIC CHURCH. Gen. Matthew Walton donated land in 1802 to build a church for the 60 families that had settled in Springfield. In 1843, work on the first St. Dominic Church was started on Doctor Street (Armory Hill). The church is named for the Dominican fathers. Fr. Joseph Hogarty built the current church on Main Street in 1894.

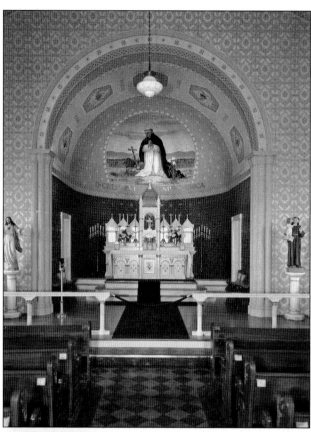

St. Dominic's Church. This picture, taken by Howard E. Gardner, shows St. Dominic Catholic Church as it was decorated in 1965. The church is currently undergoing a capital campaign drive to raise funds to restore the interior and portico (shown here above the altar) to their historic and original beauty. A new building and kindergarten will also be added.

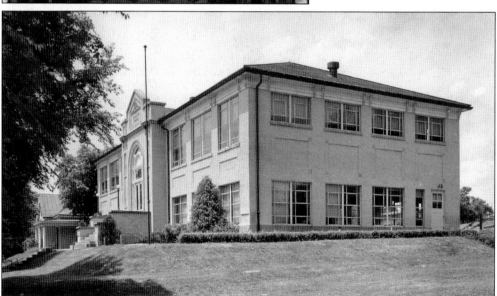

St. Dominic's School. In 1928, Fr. James Maloney had the old rectory razed and built the new Main Street School for under $30,000. The school was dedicated in August 1929. Dominican sisters were to run the school and teach. St. Dominic's finally had a permanent school facility. Today the school has expanded with several additions to the original building, seen in this picture.

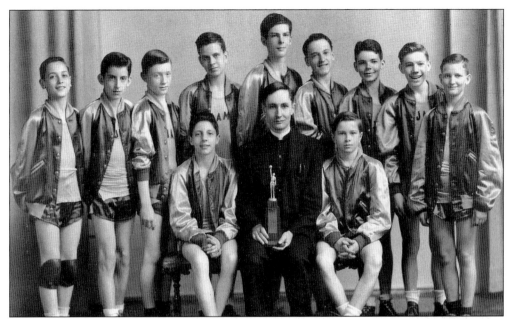

COACH FOR 30 YEARS. Fr. J. T. Blandford coached basketball and served the parish community at St. Dominic's school for over 30 years. He is pictured here as a young priest (seated holding a trophy) with one of St. Dominic's first teams, decked out in satin uniforms, leather shoes, and kneepads. (Pam Breunig and Rev. Trumie Culpepper Elliott.)

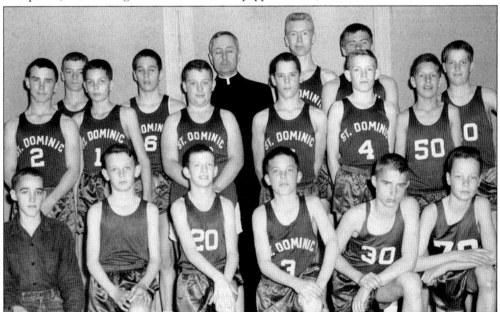

ST. DOMINIC BASKETBALL TEAM, 1955–1956. Pictured from left to right are the following: (first row) Hal Barber, Howard Carey, David Louis Ball, Hugh Lee Smith, Joe Ballard, and Cooper Bolderick; (second row) Frank Peters, Rafe Boldrick, Bill Polin, Charles Montgomery, Mac Warren, Donnie Osbourne, and Alex Simms; (third row) Frankie Clements, Rubel Montgomery, a much grayer Fr. J. T. Blandford, Charlie Haydon, and Perry Carrico. (Pam Breunig and Rev. Turmie Culpepper Elliott.)

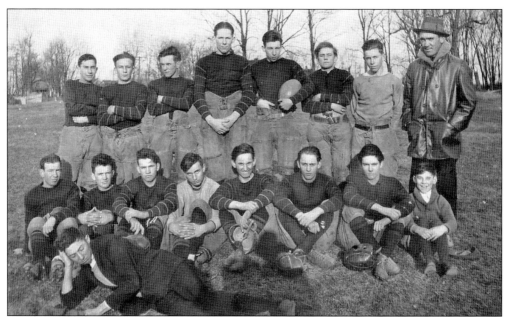

SPRINGFIELD HIGH SCHOOL FOOTBALL TEAM. The 1924 football team is seen here as they played—without helmets or padding. They stand with their coach, who is in the leather coat. The only player identified in this picture is George Lloyd Haydon (1906–1987; top row, fifth boy from the left). (Mary Barber.)

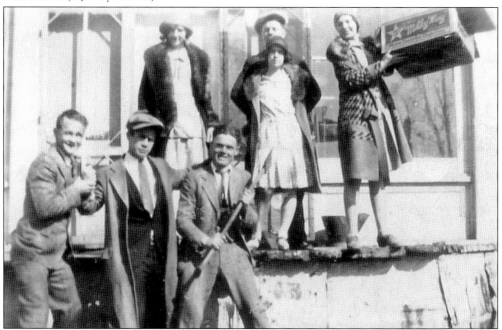

AN OLD HIGH SCHOOL PLAY REENACTMENT. In the first row from left to right are unidentified, Donnie Wilham, and Richard Hamilton. Standing from left to right on the platform are Artie Pearl Riley, Marshall Ryan (standing behind), and Sarah McMillan. The woman holding the box marked "Milky Way, 5¢" is Ruby Mudd. On the bottom row, from left to right, are Ike Hardin, J. T. McIlvoy, and Richard Hamilton. (Bobby Cheser, Gwinn Hahn, and Devola Moore Haag.)

THE BROTHERS' DORMITORY.
St. Rose was the founding house of the first religious order established in the United States. The priory opened in 1807. The college building was dedicated to St. Thomas Aquinas in January 1809. The church opened for services in 1809. The Dominican fathers erected churches all over Kentucky, including Springfield, Thompsonville, Manton, and Fredericktown. Fifty years later, St. Rose Church, which stands today, was constructed. (Jane O'Bryan.)

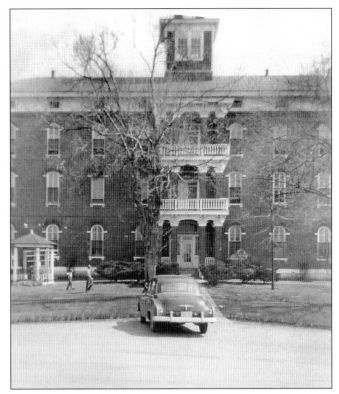

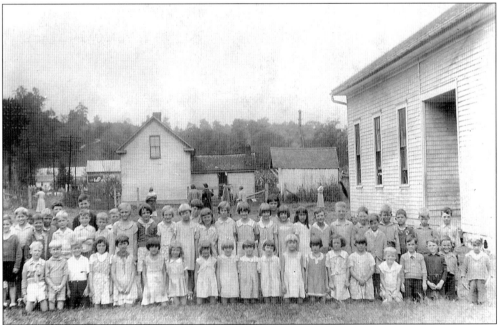

BURG CLASS PHOTOGRAPH. All the children attending the Fredericktown, or "Burg," one-room schoolhouse in grades one through eight had a school photograph taken in the late 1930s. The Ursaline sisters ran the school. Behind the children, women from the residence next door are working outside. (Louise Nally.)

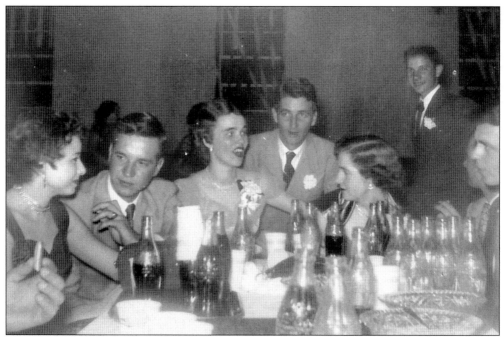

SOCIALIZING. Half the fun of the St. Patrick's dance at St. Rose was seeing friends and catching up on one another's news and adventures between dance sets. Seated here are Glenn Begley (second from the left), Rita Luckett (center), and Patricia Osbourn (fifth from the left). The Catholic Youth Organization was one of the best means in the county for young Catholics to meet each other. The organization was active well into the 1970s. (Jane O'Bryan.)

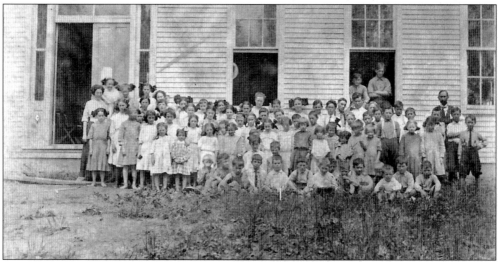

WILLISBURG, 1940. Pictured are the following: (first row, seated) Leroy Matherly, Doris Arnold, R. C. Coslow, Ruth Hayes, Eugene Birch, Peggy Devine, Billy Peavler, Belle Hardin, Billy Joe Kays, Dwayne Harlow, and Louise Beavers; (second row) Freddy White, Buddy Stump, Donald Stump, Francis Cheatum, Jimmy Cheatum, ? Yates, ? Beavers, ? Beavers, Pauline Sharp Lavonne Thomas, and Francis Mattingly; (third row) Donald Gorden, Eugene Simms, unidentified, Bertie Stump, Bobby Cheser, Francis Hardin, Billy Cheser, Maxine Perkins, ? Perkins, Beadie Hardin, Kenny Coulter, and Juanita Hilton. (Billy Cheser.)

REPORT CARD. Darrol Foster's third-grade report card from Willisburg School in 1929–1930 reveals some pretty tough grading standards. He was "conditionally promoted to the fourth grade." (Billy and Betty Jane Cheser)

Washington County Schools

J. F. McWHORTER, Superintendent

SESSION OF 19 29 - 30

REPORT OF Darrol Foster.

GRADE	TEACHER
III	William Carey

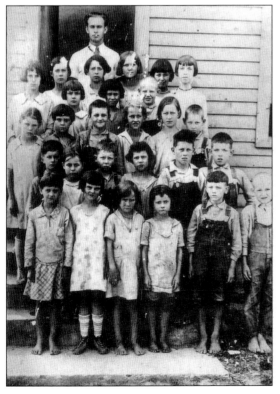

CHERRY GROVE SCHOOL. This one-room schoolhouse is on Battle Road outside of Mackville. Pictured from left to right are the following: (first row) Serina Thompson, Alma Ruby Darland (wearing shoes), Juanita Darland, Helen Sims, James Votaw, and Ruel Devine; (second row) James McMillan, Blane Baker, Arlie Votaw, Ruby Sims, Amon Baker, and Lonnie Votaw; (third row) Marie Baker, Martha Thompson, Raymond Thompson, Iva Jewel Darland, Edith McMillian, and James Devine; (fourth row) Mable Baker, Beulah Sims, and Julius Devine; (fifth row) Vertamae Salmon, Blanc Sims, Sadie Darland, Lilian Isham, Lilian Devine, and Lola Votaw. Teacher Freddie Lake is standing at the top of the stairs. (Helen and Kenneth Gabhart.)

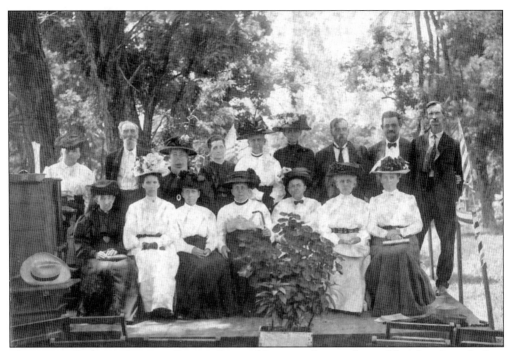

MACKVILLE BAPTIST CHURCH PICNIC. Pictured here are the members of the church in the late 1880s at the home of Dave Matherly on Willisburg Road. From left to right are the following: Nannie Mack (grandmother of Walter Foley), Kate Britton, unidentified, Ida Crawford, (mother of A. B. Crawford, unidentified (granddaughter of Dorothy Raybourne Thompson), unidentified (granddaughter of Anna Cocanougher), and Fanny Bottom; (second row, standing) Mary Anne Mayes, Billy Bowles, Martha Milton, Betty Hall (without a hat), Nannie Webb, Jane Lawson, Reverend R. L. Purdom, W. F. Hall, and John Gillespie. (Helen and Kenneth Gabhart.)

WILLISBURG HIGH SCHOOL

BASKETBALL SCHEDULE

1951 - 1952

. 13	SALVISA	Home
. 16	OLD KY. HOME	There
. 21	SPRINGFIELD	Home
. 23	WESTERN	There
. 27	BLOOMFIELD	There
. 30	LEBANON JUNCTION	There
. 4	MACKVILLE	Home
. 7	OLD KY. HOME	Home
. 14	WEST POINT	Home
. 18	SHEPHERDSVILLE	Home
. 21	FREDERICKSTOWN	Home
. 4	TAYLORSVILLE	There
. 8	SPRINGFIELD	There
. 11	MT. WASHINGTON	Home
. 15	MACKVILLE	There
. 18	LEBANON JUNCTION	Home
. 21 - 25	SALT RIVER VALLEY TOURNEY	
. 29	TAYLORSVILLE	Home
. 1	BLOOMFIELD	Home
. 5	SHEPHERDSVILLE	There
. 7 - 9	COUNTY TOURNEY	
. 12	FREDERICKSTOWN	There
. 15	SALVISA	There
. 19	WESTERN	Home
. 22	MT. WASHINGTON	There

Sponsored by

J. C. ROBINSON & CO.

WILLISBURG HIGH SCHOOL BASKETBALL SCHEDULE. This is the schedule for the Willisburg basketball team during the 1952–1953 school year. Because each city had its own high school team, there were "spirited" rivalries between Willisburg, Mackville, and Springfield. The team sponsor was J. C. Robinson and Company. (Billy and Bobby Cheser.)

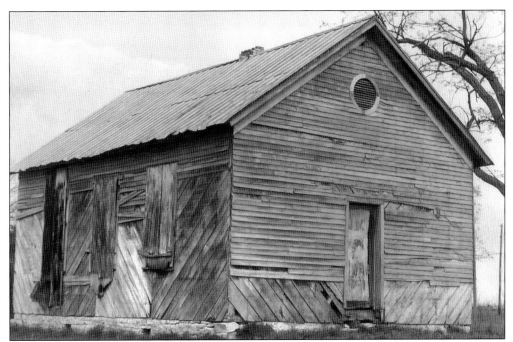

BRINGLE SCHOOL. Off Highway 1183, on the farm of Nina and Paul Smith, stands a one-room schoolhouse. Bringle School, built around 1900, is named for Bringle Place farm. The foundation is made of hand-hewn rock and still inside is the original blackboard, pot-bellied stove and ledge where children placed tin cups and sack lunches. School was scheduled around the growing/harvesting season and lasted 146 days. (Nina and Paul Smith.)

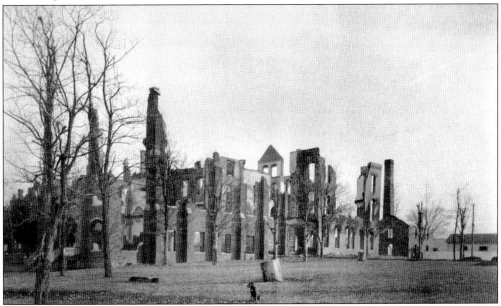

FIRE DESTROYS SIENA VALE ACADEMY AND MOTHERHOUSE. In 1904, a disastrous fire destroyed Siena Vale Academy and Motherhouse. The Dominican sisters of St. Catharine rebuilt immediately and relocated to another site. By the fall of 1905, students were learning in the partially completed academy. (Sr. Rosemary Cina and St. Catharine Motherhouse.)

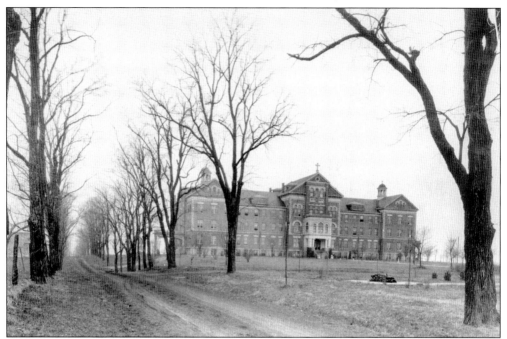

ST. CATHARINE MOTHERHOUSE. Located two miles west of Springfield, on U.S. Highway 150, St. Catharine College is an independent, two-year, coeducational Catholic college founded in 1931 by the Dominican sisters of Kentucky. They established the first school in 1823 and began granting educational degrees in 1839. In 1904, fire destroyed the academy, and the motherhouse was built shortly thereafter. A bachelor's degree program was offered for the first time in 2004. (Kentucky History Center and St. Catharine College Web site.)

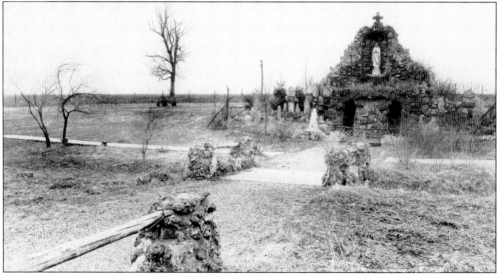

THE GROTTO. The grotto at St. Catharine Academy, in 1920, depicts the Virgin Mary appearing to St. Bernadette in Lourdes, France. The school charter was amended in 1920 to create colleges and grant degrees. The academy became a normal school and then a college in 1931. Originally a women's academy, the college became coeducational in 1951. St. Catharine College achieved regional accreditation in 1958. (Kentucky History Center.)

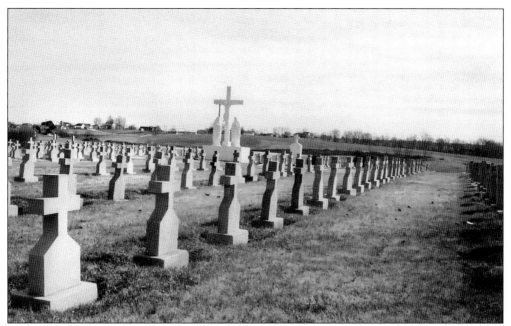

WHITE CROSSES. Overlooking a small lake are over 1,100 graves of Dominican sisters who have worked and lived at St. Catharine Motherhouse since its inception. The white crosses are lined up neatly in military fashion.

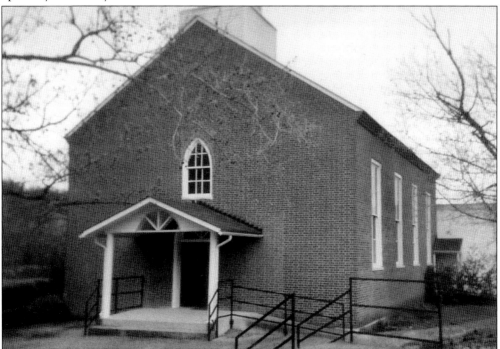

HOLY ROSARY CHURCH IN MANTON. This wonderful old parish church was built in 1844 in Manton, once known as Blincoe, Kentucky. Fr. Chris Allegra is responsible for both this church and the Holy Trinity Church in Fredericktown. The building is listed on the National Register of Historic Places and has been remodeled and updated in recent years.

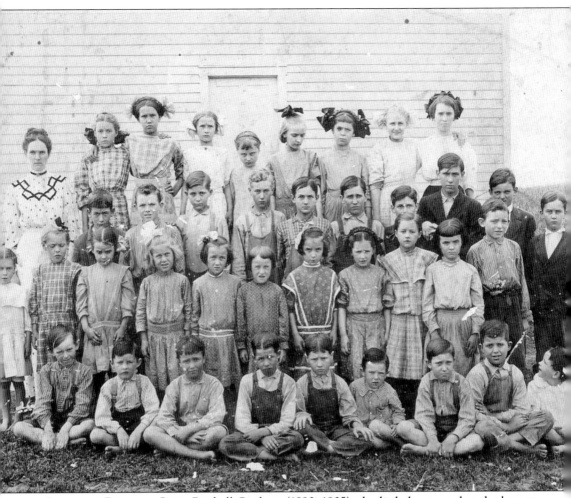

STANDING BESIDE A GIRL. Birchell Cooksey (1890–1905), the little boy seated at the bottom right row, is too young to be at White Hall School, but he came anyway so that he could have his picture made. He is looking up and laughing at his brother Willie Cooksey because he's standing beside, of all things, a girl! Willie died at the age of 11 of appendicitis. The children in this 1893 one-room schoolhouse picture are, from left to right, as follows: (first row, seated) Russell Cooksey, Raymond Goff, Cecil Keeling, Frank Carey, Howard Wright, Bill Riley, John Devine, Harvey Young, and Birchell Cooksey; (second row, standing) Mary Hickerson, Odell Tarrier, Nannie Kate Devine, Gillie Farris, Mary Hayes, Martha Hayes, Bonnie Hayes, Lola Riley, Mae Goff, Nettie Masters, and Willie Cooksey; (third row) Marvin Carey, Pascall Cooksey, Dewey Young, Dewey Prewitt, Elmer Hayes, Clay Shewmaker, Ellis Hickerson, Hughie Riley, Opha Cooksey, and Marshall Bottom; (fourth row) teacher Emma Bell Hyatt, Ophia Goff, Lillie Devine, Reta Hayes, Lucy Milburn, Birdie Shewmaker, Mary Riles, Jewell Hyatt, and Maude Devine. (Billy and Betty Jane Cheser.)

Three

FAMILIES AND FRIENDS

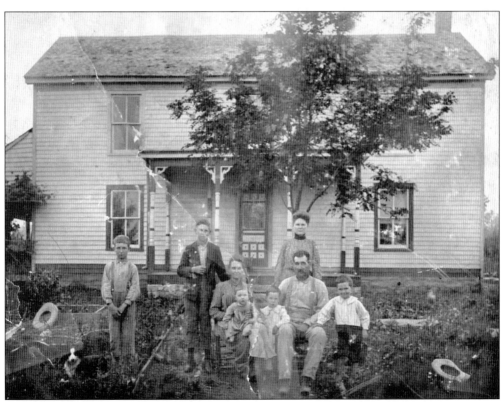

THE RICHARD M. AND ANNA OSBOURN FAMILY. Richard M. (seated) and Anna Osbourn (holding a baby) had five children when this picture was taken at the beginning of the century. The children went to Smith School on Booker Road. Richard Osbourn's mother stands behind him. The family dog is in the lower left hand corner of the picture. The Osbourn family home on Lebanon and St. Rose Roads would later be passed down for three generations. (Joyce Taylor and Patricia Ewing.)

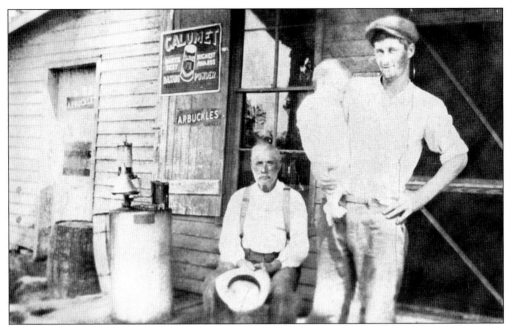

BELL FAMILY PORTRAIT. William Edward Bell is seated on the front porch of his general store in Bearwallow, Kentucky, located in Washington County. His son, Austin Miles Bell, is holding his baby son, James Eugene, at right. An advertisement for Calumet baking powder can be seen in the background. (Kentucky History Center.)

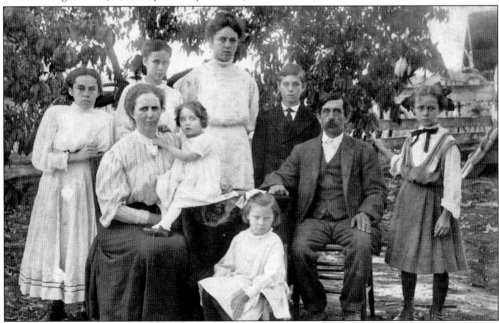

FIELDS FAMILY PORTRAIT. In 1904, in Manton, Sidney Fields stands on a stool. Her mother, Adeline Brent Fields, is holding her daughter Rosie, who later lived at the state asylum for the "feeble-minded." Stella, with a back deformity, is standing to her mother's left. Behind Adeline, from left to right, are her daughters Praxie and Florence and her son Walter. In front of Walter are his father, Burr Fields, and his daughter Annie. (Kentucky History Center.)

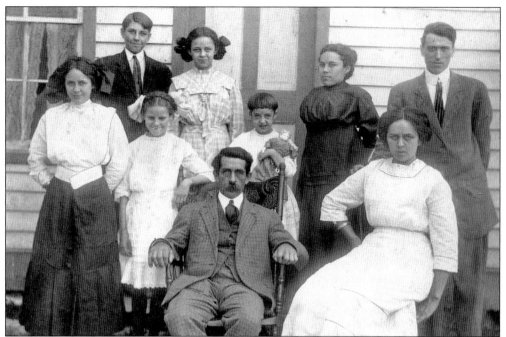

THE FIELDS FAMILY. This picture, taken in 1911, shows Burr Fields sitting in the center; his daughter Alma is to his right. In the second row, from left to right, are Praxie, Sidney (Mary Margaret Bell's grandmother), and Rosie (holding a doll), Stella, and an unidentified young man. In the back are Walter and Annie. Rosie was holding Sidney's doll, which she later broke. (Kentucky History Center.)

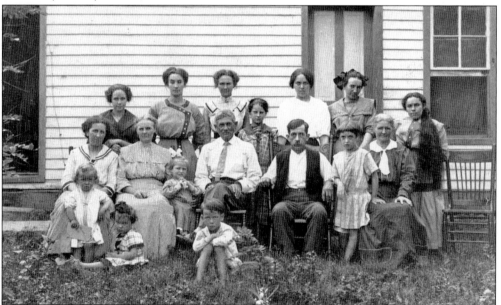

AN EXTENDED FAMILY PORTRAIT. The Fields family of Manton sat for this photograph in 1908. Sidney Fields (later Coligan), who was Mary Margaret Bell's grandmother, is the small girl in the center. Stella is the young woman on the right with the long black hair. (Kentucky History Center.)

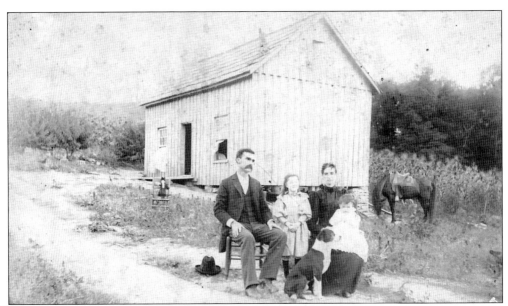

ALL THAT I HAVE AND LOVE. John Burton Jenkins, seated, (April 18, 1867–March 20, 1944) is pictured with daughter Effie Anna Jenkins (December 11, 1890–October 10, 1961). His wife (seated), Martha Jane Keeling Jenkins (June 27, 1867–January 15, 1937), is holding Auda Ethel Jenkins (July 23, 1895–July 23, 1971). In 1890, the house with native windows (no glass) was on Tatum Road, in Willisburg, overlooking the Chaplin River. (Betty Jane Cheser.)

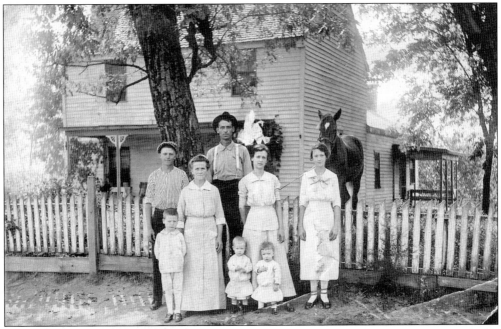

THE HAYES FAMILY. This 1916 photograph of the Hayes family on Battle Road in Mackville shows, from left to right, Garnet Hayes, Nannie (Roberts) Hayes and her infant daughter Willie Ann (Hayes), Iva Hayes Taylor along with her daughter Jewell Taylor, and Pearl (Hayes) Peavler. On the back row are Lonnie and William A. Hayes. The children in the front row were aunt and niece. (Helen and Kenneth Gabhart.)

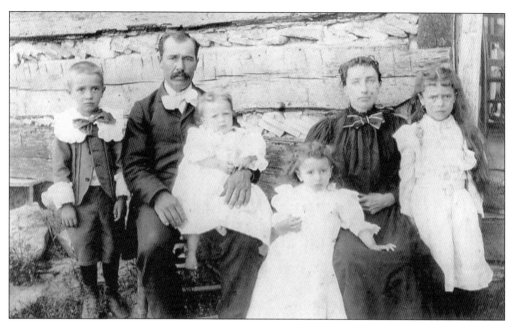

LOG CABIN. These early pioneers, pictured here in 1897, built their log home by hand, felling trees, making beams, and back filling the log structure with mud, fieldstones, and other materials. Standing left to right beside his father is Hansford Wilham, R. A. Wilham (sitting) holding Dora Wilham in his lap. Dorothy stands beside her mother, Sarah (sitting), and Lilus Wilham is closest to the cabin. (Billy and Betty Jane Cheser.)

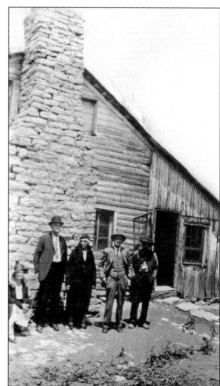

BOTTOM HOMESTEAD. This 1934 picture is of the Bottom family at their homestead in Deep Creek. The house is made of hand-hewn rock and hand-cut timber. (Bob Bottom.)

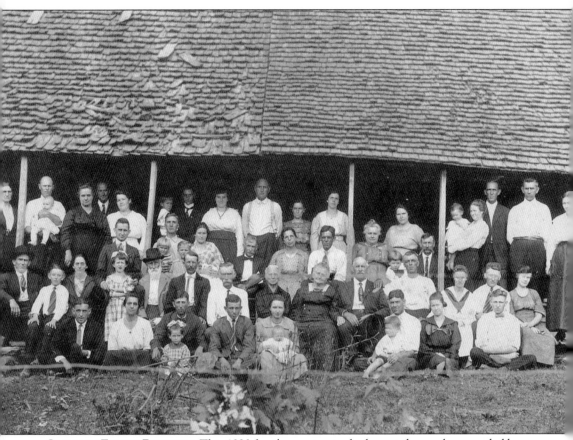

GABHART FAMILY REUNION. This 1920 family reunion took place at the newly expanded home. Pictured from left to right are the following: (first row) Tommy Taylor, Ethel Young Roberts, Hansford Roberts, Lavena Roberts (in front of her dad), Lee Trower, Ethel Trower, baby Trower, Edgard Young, Roy Young (in lap), Maggie Trower, and Roy Gabhart; (second row) Carter Hall, ? Hall (boy), Laura Taylor Hall, Louise Trower, Seth Gabhart, Ode Trower, John Taylor, Liza Young, Maggie Gabhart, Steve Grant, unidentified child, George Young, Dora (Gabhart) Shewmaker, Clay Shewmaker, and Ressie Bottom; (third row) Dr. W. S. Gabhart, ? Gabhart (child), ? Gabhart (child), Morgan Gabhart, Lottie (Roberts) Gabhart, Henry Hickerson, Janie Hickerson, Vick (Young) Yancey, and Will Young; (fourth row) Cora Little, Bill Little, Baby Elwood Little, Ada Trover, unidentified, Marie (Jameson) Gabhart, Vernon Moore, Edwin Moore (child), Lena Moore, Elijah Gabhart, Mary (Taylor) Gabhart, Bertha Young, Josie Settles, Bruce Gabhart (child), Matilda Gabhart, C. T. Gabhart, Will Gabhart, and Georgia Gabhart. (Helen and Kenneth Gabhart.)

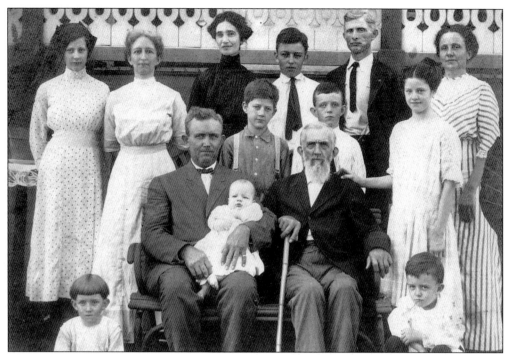

JOHN ABSOLOM TUCKER FAMILY. The children seen sitting on the ground in this 1912 photograph are Gladys Louisa Tucker and Cosby Tucker. Also pictured from left to right are the following: (first row) James Washington Tucker, James Norris Tucker, John Tucker, and Martha Ann McIntyre; (second row) unidentified and John Tucker II; (third row) Thelma Louisa McIntyre, Jean Tucker, Mary Florence Phillips, Victor Tucker, Dr. E. L. McIntyre, and Nora Estelle McIntyre. (Nick McWhorter.)

HOME ON LEAVE. Richard Patrick and Mary Elizabeth Abell stand together in front of his childhood home outside of Springfield on Booker Road. The couple married in 1945, had seven children, and lived on a nearby farm. In addition to farming, Richard owned a gas station on Main Street and operated a milk route in Washington County for many years. This photograph was taken in 1943 when he was home on leave during World War II. (Laurie Smith.)

NEW IN-LAWS. Joseph A. and Mary Smith Osbourn and Clarence and Lucy Ewing pose for a picture as new in-laws and parents to the newlyweds Patricia (Osbourn) and Glenn Ewing. (Jane O'Bryan.)

O'BRYAN BOYS. T. W. and Mary O'Bryan pose with their nine sons in 1958 at Easter. Kneeling are Foster, Billy, Buddy, and Freddy O'Bryan. In the second row, from left to right, are the following: T. W. O'Bryan (holding hat), Bob, Joe, Bernard, Mike, Junior, and Mary O'Bryan (wearing a hat). (Jane O'Bryan.)

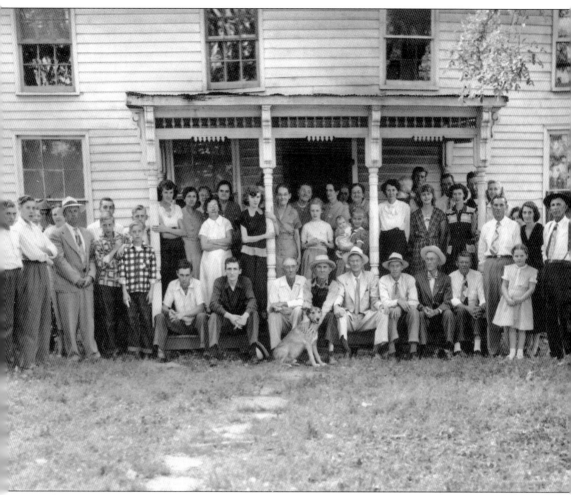

CHESER FAMILY REUNION. The Cheser family reunion in 1950 was held at the house of Sally and Harvey Cheser on Hardesty Road. From left to right, standing on the left of the porch are N. Leo Hardest, Billy Kidwell, Elizabeth Begley, Clifton Murphy, Myrtle Murphy, Gus Begley, and unidentified boys. Seated from left to right are Sherrill Lyvers, Bob Walker, Gilbert Cheser, Clarence Cheser, Lem Cheser, G. S. Kidwell, Roy Cheser, and Herbert Cheser. Pictured in the first row are Kenneth Kidwell, Frances Spiaggi, Ruby Kidwell, and Bob Cheser. On the porch from left to right are Zelma Lyvers, Effie Carney, Gladys Kays, Martha Kidwell, Laura Cheser, Ann Walker, Betty Kays, Emma Kidwell, Elizabeth Bauer, Lucy Cheser, Margaret Kidwell, May ?, unidentified girl holding a baby, Martha Mattingly, C. H. Kidwell, Frances Mattingly, Jack Kidwell, Frances Carney, Herman Durr, Joyce Durr, and Icie Cheser. (Billy and Betty Jane Cheser.)

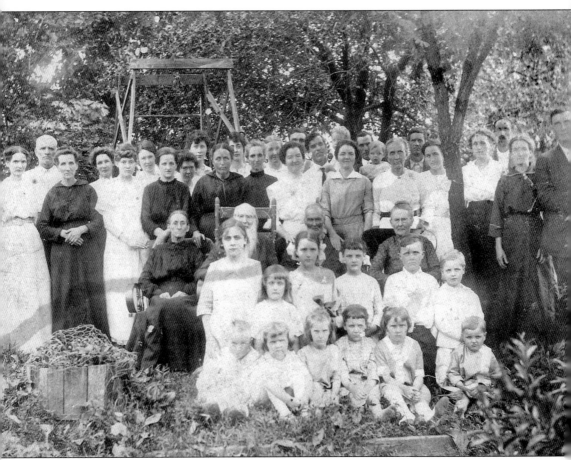

BIRTHDAY DINNER EXTRAVAGANZA. Martha Jane Jenkins of Mackville celebrated her 48th birthday in 1915. Sitting on the ground, pictured from left to right are the following: (first row) Ashby (?), Ruby Keeling (?), Ella Mae Jenkins Johnson, unidentified, Edna Ashby, and Vernon Keeling (Elmer's son); (second row) Martha Thompson, Dorothy Keeling, Marjorie Jenkins Cooksey, Rae Keeling Royalty, Elmer Ashby, Pascal Keeling (Elmer's son); (third row) Mrs. Dennis (Lizzie Keeling's mother), Uriah Keeling, George Waller Jenkins, and unidentified; (fourth row, standing) Bertha Keeling, Mary Ellen Shields, Dovie Scruggs, Lizzie (Elmer) Keeling, Edie Sims (behind), Susie (Jim) Keeling, Martha Jane "Ma" Jenkins, Effie Jenkins Bishop, Auda Jenkins Crocker Kay, ? Pinkston (Oari Keeling's mother), Ethel Keeling (Jim's daughter), Oari (Evan) Keeling, Gerthie Keeling Ashby, Clarence Ashby, and their son; (fifth row, standing) Clay Foster, Nannie Keeling Bishop, Winnie Scott, unidentified, Sarah Keeling Wolf, unidentified, John Burton "Pa" Jenkins, Evan Keeling and son, Elmer Keeling and son Hershel, Ben Keeling, and Jim Keeling. (Betty Jane Cheser.)

TINY BARE FEET. Long before it was fashionable to have children's pictures taken with their shoes off, Birchel Cooksey standing (1905–1990) and Mae Bird Cooksey Hale (1908–) had their picture taken in their bare feet. Mae Bird was the only girl in a family with six brothers. Their parents were Luther and Annie Cooksie. Standing behind them is a picture of the horse that pulled the wagon they arrived on. (Billy and Betty Jane Cheser.)

GREAT GRANDCHILDREN. Miranda Scott of Mackville is proudly holding Larry Jo Scott, her great-grandson. Standing are, from left to right, her other great-granddaughters Jane Pinkston, Brenda Pinkston, and Judy Scott. (Mary Helen Russell.)

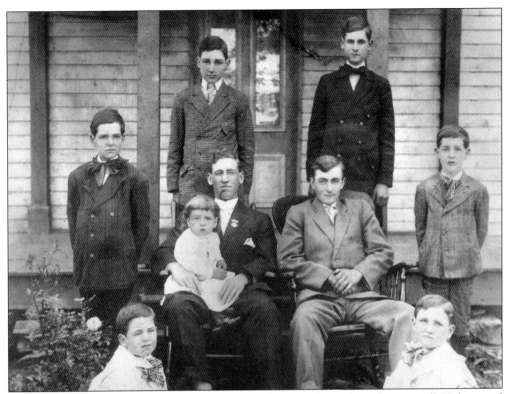

NINE BOYS. Pictured from left to right are the following: (seated on the ground) Hubert and Sydney Osbourn; (second row, seated) Willie (holding baby Leo), Leo, and Victor Osbourn; (third row) Richard and Walt, Bernard, and Joseph A. Osbourn. Leo and Sydney later became Dominican brothers at St. Rose Priory. (Patricia Ewing and Joyce Taylor.)

BABY BROTHERS. Reed (left) and Taylor Spaulding at three years and 20 months old. Both boys grew up in Springfield and owned the Spaulding Tractor and Farm Equipment Company. They allowed farmers to pay on time for their farming equipment. (Taylor Spaulding.)

ONE HUNDRED FULL YEARS. George Waller Jenkins (seated) is pictured here at 100 years old on March 18, 1817. He died at the age of 101 years, one month, and 12 days old. He is pictured here with an unidentified grandchild (standing). He had 18 children and was married twice. (Billy and Betty Jane Cheser.)

FOUR GENERATIONS. Seated on the right is Martin Vanburen Crouch with his son, grandson, and great-grandson. Martin Vanburen Crouch is on the right, his son James Barbour is standing, and Barbour's son Lester Van is holding his infant son Lester Eugene Crouch. (Gwinn Hahn and Devola Moore Haag.)

ONE OF THE FAMILY. It's pretty tough for a small child to understand. If the ewe rejected the lamb, the children of the family hand fed it, combed out its wool, and made it so tame it followed them like a little dog. For the children, it was one of the family. The culmination of all that love and work for the children's pet was the money it brought at market. During wartime, every penny was needed to raise a family. (Jane O'Bryan.)

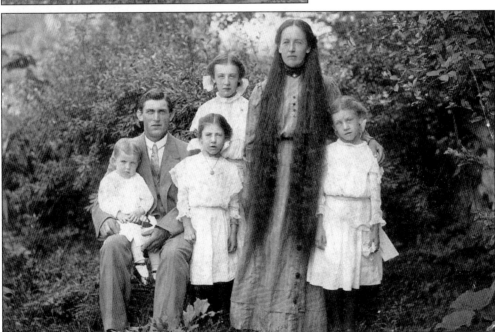

THE HAYES FAMILY. John T. and Alma Hayes had four little girls (unidentified). The style for women in this time period was to wear their hair up in a bun and away from the face. Alma Hayes had her hair down the day this picture was taken. Her long locks hadn't been cut since she was girl. (Helen and Kenneth Gabhart.)

PRETTY AS A PICTURE. Mary Margaret Pinkston had her picture taken in 1908 at the age of two. She was born in 1906, the daughter of William Nelson Pinkston and Betty Lillie Haynes Pinkston. (Wayne Pinkston.)

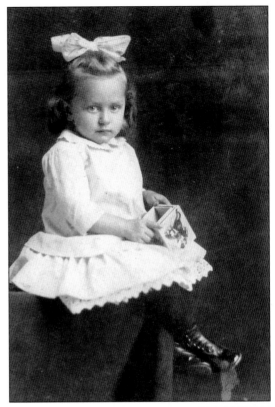

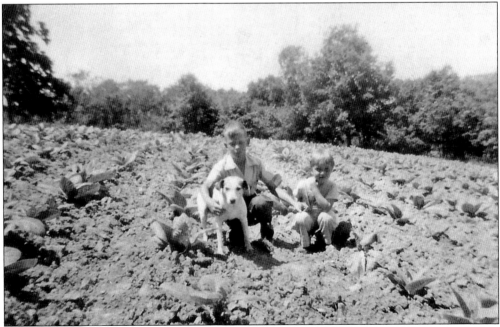

SNAKE DOG. Wayne Pinkston and his sister Marsha are pictured here in the tobacco field of their grandparents' Willisburg farm in 1950. The family dog's renowned ability to kill snakes on the farm was, in the end, fatally bitten. (Wayne Pinkston.)

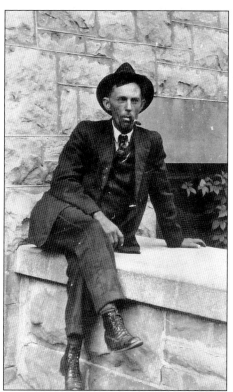

HAVING A CIGAR. Born in 1871, Derwin Pinkston enjoyed smoking his cigar on the steps. He was kicked in the head by a horse as a young man in Willisburg and was never quite the same after that. Derwin Pinkston was one of six children born to John T. Pinkston of Willisburg. (Wayne Pinkston.)

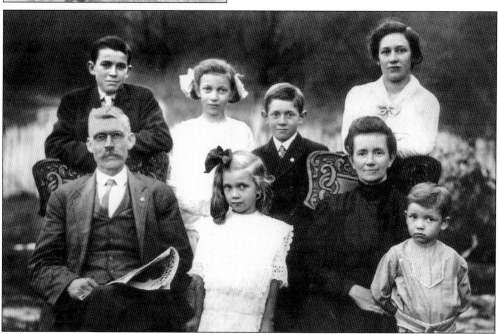

IN SUNDAY BEST. The Taylor family poses for a family photograph in 1914. Pictured from left to right are the following: (first row, seated) Ben Taylor, Bernadette Taylor, Kate Taylor, and Gene Taylor; (second row) Chester Taylor, Violet Taylor (bow in hair), Albertus Taylor, and Gertrude Taylor (woman standing). (Buddy Taylor.)

MOTHER AND SON. Jayne Mae Osbourn and her son William posed for this photograph in the early 1940s. (Joyce Taylor.)

A DEVOUT WOMAN. Victoria Riney Smith is holding her Rosary and wearing a cross around her neck. Religion was one of the centerpieces of social life, entertainment, and community in rural Washington County in the late 1800s. She married into the Smith family when she was just 16 years old. This photograph was taken in front of her home in 1880. She died in 1945 at the age of 89. (Joyce Taylor.)

YOUNG COURAGE. Tom Smith stands in front of the family barn and his Model T Ford. A boy himself at 16 years old, he holds his baby son Richard in 1928. Life was about to get a lot harder, as the Great Depression loomed. (Joyce Taylor.)

ALL DRESSED UP. Mary Katherine Mattingly is thrilled to have her photograph made in her new 1920s flapper dress in front of the feed trough on the family farm. (Joyce Taylor.)

HE CAME BACK! These girls (left to right) are Jane, Patricia, Joyce, and Thelma (holding Elizabeth Louise Osbourn). The dog was a pet. Like many farm families, the Osbourns felt that a biting dog could not be kept, and their brothers were told to kill the dog. Their hearts weren't in the job and the dog came home a few days later, never to bite again. (Patricia Ewing and Joyce Taylor.)

ENJOYING A QUIET MOMENT. Louise (Fields) Smith sits in her front yard with the hydrangea bush, or "snow ball tree," as people call it, for a few stolen moments of tranquility. She was married to Paul Smith on December 22, 1943. A busy mother of several children with lots of work to do, a few minutes of peace and quiet were considered a luxury. (Joyce Taylor.)

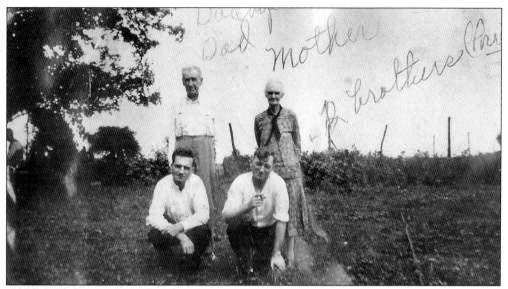

THE PICTURE OF DEVOTION. In this image, Father Leo and Fr. Sydney Osbourn have come home to visit their parents Richard and Annie Osbourn. Richard and Annie raised nine boys on their farm. Annie died on May 3, 1945. (Joyce Taylor.)

NEAR TEARS. Getting young children to pose for pictures can be a difficult task. If not handled with the right finesse, tears can flow. Ann Osbourn, of Springfield, at two and a half years of age is a little scared and has had all she can stand. Near tears and dressed in her best clothes and shoes in 1940, she waits for the photographer to finish his work. (Joyce Taylor.)

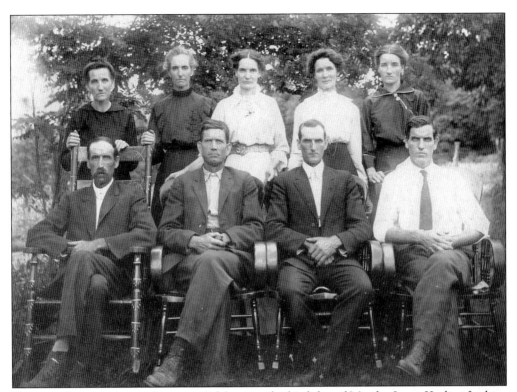

Keeling Brothers and Sisters. Celebrating the birthday of Martha Jones Keeling Jenkins on June 23, 1915, are the Keeling brothers and sisters at the home of John Burton and Martha Jane Jenkins. Pictured from left to right are the following: (first row, seated) Jim, Ben, Elmer, and Evan Keeling; (second row, standing) Mary Ellen Shields, Martha Jane Jenkins, Bertha Foster, Nannie Bishop, and Girthie Ashby (Billy and Betty Jane Cheser.)

Pope Brothers. In the beginning of the 20th century, it was acceptable to dress young boys in this type of clothing. Boys and girls were often dressed alike in photographs. Pictured here are the Pope brothers. This picture may have been taken at their grandfather's home. (Larry Randolph.)

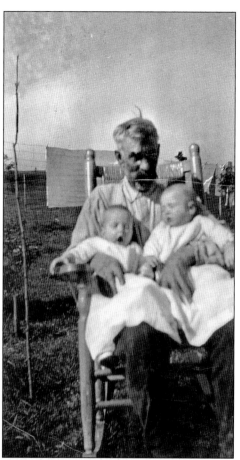

ON GRANDPA'S KNEE. Rudy (left), born October 3, 1923, and Russell Pinkston, born October 8, 1923, are sitting on their grandpa's lap, John T. Pinkston (1854–1941). They were first cousins born five days apart. Russell died at the age of nine from blood poisoning that resulted from a facial burn he sustained when he fell on a hot stove. (Wayne Pinkston.)

ONE STRONG LADY. Della Pinkston, heartbroken and distraught, is kneeling over the grave of her nine-year old son, Russell Pinkston. This picture was taken on the day he was buried in the Willisburg Cemetery. (Wayne Pinkston.)

Four

WORK AND DUTY

BRING IN THE CALVARY. These fine young men from Springfield are working hard as farriers and doing their duty in the U.S. Calvary to preserve freedom back home. They are preparing to put shoes on two strong mules so they can pull wagons in World War I. (Nick McWhorter.)

CHANGING THE FACE OF DOWNTOWN. Wayne Pinkston changed downtown Willisburg by reclaiming this building, opening the museum and creating the Willisburg History Center. Pinkston recreated the 1940s pharmacy counter at the Main Street Museum and collected the original medicine bottles on display. In addition, he recreated a doctor's office, post office, and a bank in the museum. He claims that collecting is not duty or work but a labor of love.

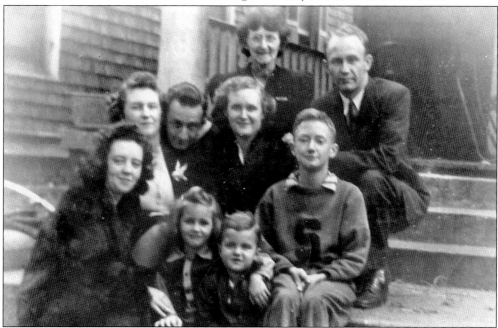

LAST DAY OF FREEDOM. This picture was taken on Thanksgiving Day, November 25, 1944, the day before Jane and Otis Buckman left for Philadelphia, where Otis would begin his service in the navy during World War II. Janice Mae and Billy Osbourn hosted the dual Thanksgiving Day feast/going away party. Pictured from left to right are the following: (first row) Claire Osbourn, and Jerry and Bubba Osbourn (children); (second row) Jane and Otis Buckman, and Bernadine and Jimmy Osbourn; (third row) Janice Mae and Billy Osbourn. (Joyce Taylor.)

TAKING THE WEEDS OUT. In 1954, seven-year-old Jane Cheser checked on her dad, William Cheser, who was tilling up the rows between the tobacco crops with a handheld, five-pronged scratcher plow. He could weed up to 1½ acres a day. The tobacco seed had been set out a month earlier and was growing nicely. It would be two months before it would be cut. (Billy and Betty Jane Cheser.)

THE LAST TEAM. In 1964, William Cheser holds the last team of horses he bought before buying a tractor. Sitting on horseback is his six-year-old grandson Roger. He bought the horses from Alex Barber on Bardstown Road in Springfield. Barber offered to hold Cheser's check until he tried the bay horses out for a week. (Billy and Betty Jane Cheser.)

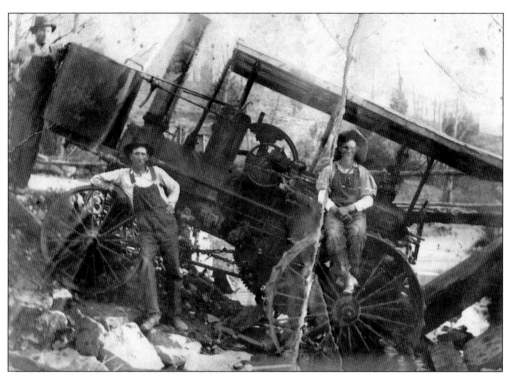

BROKEN BRIDGE. This wooden bridge collapsed in 1915 under the weight of the steam-powered engine. In the silence of the countryside, people heard the large crack and collapse of the bridge for miles around. Leaning on the front wheel is George Barker, and sitting on the rear wheel is Arthur Harmon. The steam engine was used to thresh wheat and other grains and grass seeds. This wooden bridge was located between Mackville and East Texas. (Billy and Betty Jane Cheser.)

DAIRY TAG. Allen Cole and Everett Brumley owned the country store in Willisburg. They bought cream from the local dairy farms and delivered it in milk cans to Louisville Creamery. This 1930s tag was placed on the milk after it was weighed and tested. Milk was sold to the Louisville Creamery until the early 1950s. (Bobby and Mary Martha Cheser and Billy and Betty Jane Cheser.)

WAR BUDDIES. Seen here are Hamp Wilham and his friends from Washington County who served with him in World War I. After a life-changing event like serving in a war together, these men were buddies for life. Celebrating his return home, Wilham "imbibed a little bit," according to Billy Cheser. When the local constable informed him that he had thirty seconds to "get gone," Hamp told him, "I'll be gone in ten!" (Billy and Betty Jane Cheser.)

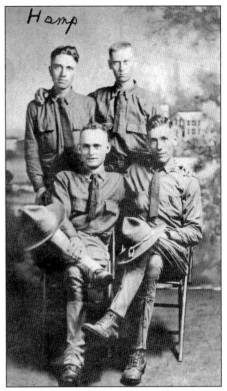

HAND-TIED TOBACCO. William Edgar Hardin drives the truck that picked up the tobacco crop after it was taken down from the barn (background) that was built in 1951. Harvested green, speared on a stake, and hung on tobacco sticks before being hung from the rafters of the barn, the leaves "cured," or dried, to a nice, soft brown. (Helen and Kenneth Gabhart.)

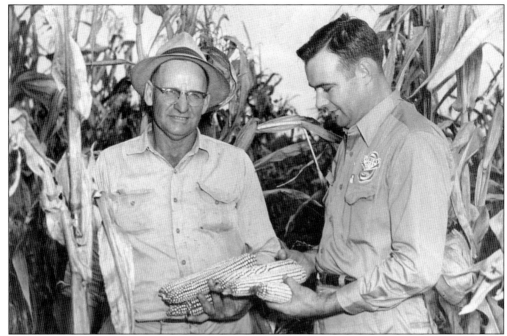

MEETING WITH THE EXTENSION AGENT. Roy Gabhart is discussing the outcome of his latest corn crop at the Southern states county extension agent in 1950. A new seed was tried that year, and the agent came out to check on the results of the crop. (Helen and Kenneth Gabhart.)

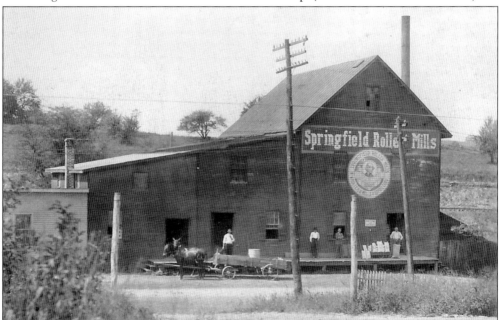

SPRINGFIELD ROLLER MILL. This business was started by J. W. Jarboe, and then passed on to his son-in-law C. R. McWhorter, who later took his son-in-law H. L. Wells as a partner. The mill was later sold to G. Lloyd Haydon and renamed Haydon Mill and Grain Company. The majority of farmers in the surrounding area brought their grains here to be milled into meal, flour, and feed. (Nick McWhorter.)

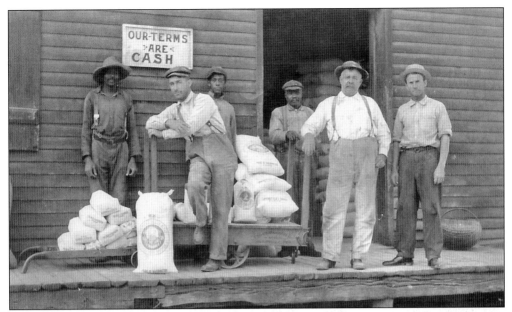

OUR TERMS ARE CASH. Owners Charles Robert McWhorter and H. L. Wells and employees pause before loading a wagon. Built in 1933 by J. W. Jarboe, this was the first mill at this location to use large millstones powered by a steam engine that rolled over the grains to produce the "Pride of Washington Flour" and Martha Washington self-rising flour, pictured on the front of the sacks in this photograph. (Nick McWhorter.)

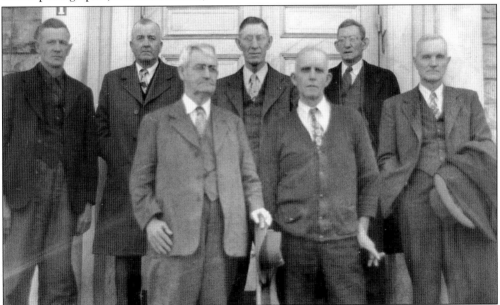

PUBLIC SERVANTS. Posing outside the Washington County Courthouse, on September 11, 1940, from left to right, are the following: (first row) Judge J. R. Claybrook, circuit clerk Cecil G. McMillin, county clerk John M. Smothers, John Burress, and county attorney H. M. "Pat" Grigsby; (second row) Joseph S. O'Daniel, assistant tax commissioner W. L. McClellan, jailer Edward S. Goatley, master commissioner Grundy Mays, and Sheriff Joseph C. Robinson. (Nell Haydon and A. H. "Bubba" Robertson.)

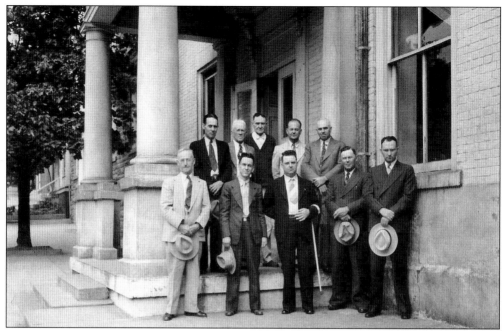

A New Year's Day Picture. Judge H. R. Eddleman poses outside the Washington County Courthouse on January 1, 1946, with magistrates, from left to right, H. K. Kimberlin, A. C. Medley, Luther Lewis, Roy Devine, Erastus Bishop, and Clyde Goatley. (Nell Haydon and A. H. "Bubba" Robertson.)

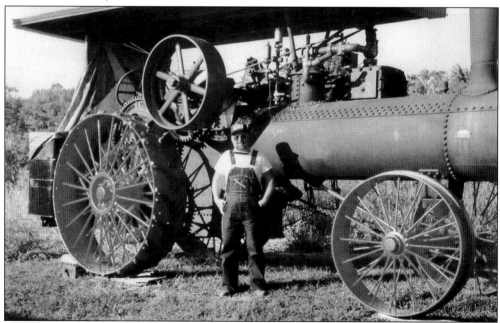

Wheat Thrasher. James Johnson stands in front of this 1897 wheat thrasher. The steam engine ran on coal and wood. Wheat was thrashed (hull removed), and it went to the mill to be ground into flour. This thrasher is still being used today on Mayes Creek Road. Willisburg and Springfield both had mills. (Billie and Betty Jane Cheser and Bobby and Mary Martha Cheser.)

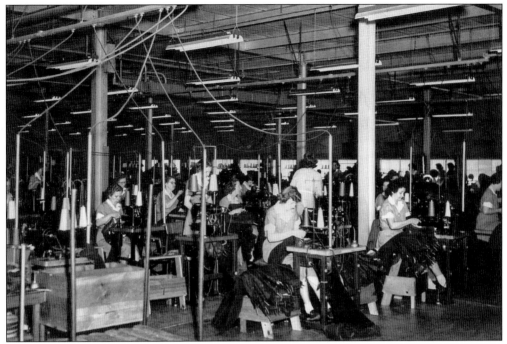

AT THE SEWING MACHINES. Cowden Manufacturing Company made pants, overalls, jackets, and coveralls sold to chain stores, by mail order, and to retailers in all 50 states and in Europe. (Mary Helen Russell.)

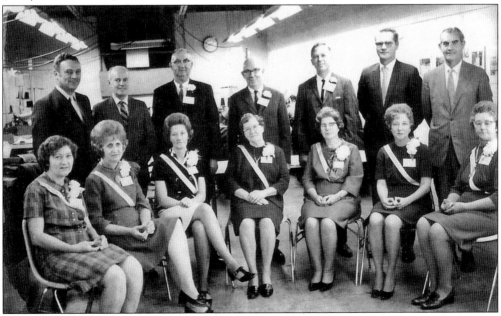

THE 20TH ANNIVERSARY. Cowden Manufacturing Company celebrated its 20th year in Springfield in 1969. The employees celebrating 20 years with the plant, from left to right, are as follows: Mary Ann Carrico, Artie Ross, Reecie Votaw, Grace Thomas, Ella Jane Goode, Hattie West, and Pauline Mattingly; (second row) plant superintendent Borgia Buckler, Shirky Green, W. West, Paul Blandford, J. Skean, Paul Arnold, and Tom Cox. (Mary Helen Russell.)

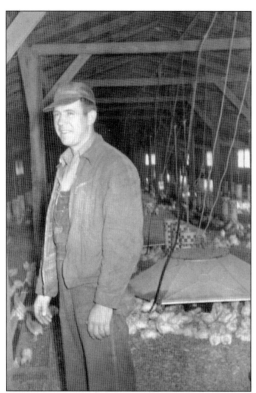

WORKING IN THE CHICKEN HOUSE.
Farmers did whatever they could to make a living, including raising turkeys and chickens, as Kenneth Gabhart (1926–2006) did on his father's farm in the 1960s. Behind him is an electric lamp brooder to keep the chicks warm. The height could be changed to control the temperature. To the left is the food and watering system for the chickens. (Helen and Kenneth Gabhart.)

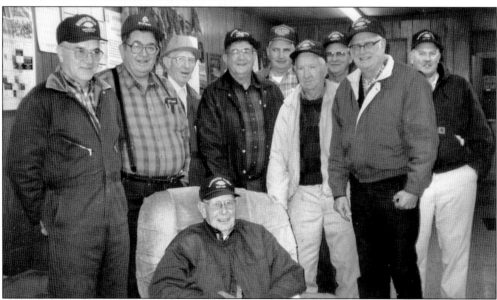

WAREHOUSE GANG. In 1997, the Washington County Cooperative's members met to sell tobacco on Lebanon Road. Sitting in the chair is the floor boss, Joe Spaulding. The men standing on the second row from left to right are Jimmy Graves, Bobby Cheser, Hoover Carney, Billy Cheser, Bernard O'Bryan, and Bob Purdom. Standing in the back from left to right are Leo Graves, Melvin Settles, and Mike Jones. These men were responsible for unloading farmers' tobacco, weighing it, and lining it up for the buyers. (Bobby Cheser.)

A LIFE OF WORKING TOBACCO. Byron Goode worked at the Loose Leaf Tobacco Warehouse in Springfield and later worked at the New Farmers Warehouse No. 2. Born in 1911 to Charlie and Della Goode, he still works part-time at 96 years old. Goode resides on his 40-acre farm in Willisburg. He was married to Mabel Shewmaker for over 65 years and had two children. (Bobby Cheser.)

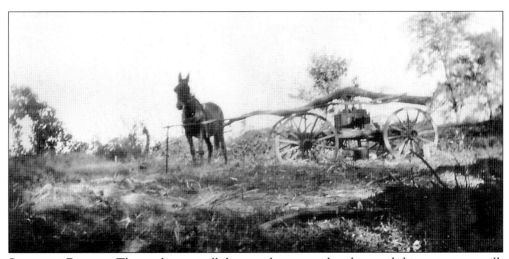

SORGHUM PARADE. This mule spent all day parading around and around this sugar cane mill. The resulting juice of the cane was cooked for hours, reducing it to a thick, sweet, and syrupy consistency. Washington County was known for its sorghum production all over the state. After 25 years, the annual Sorghum Parade was discontinued in 2006. (Ollie Gray Pinkston Clark.)

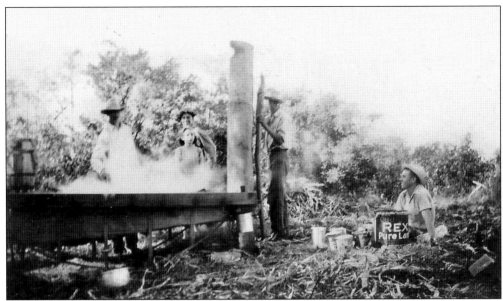

COOKING SORGHUM DOWN. This empty Rex Pure Lard bucket was used to store sorghum. The sugar cane juice was cooked in a large, shallow, stainless steel vat heated underneath by a wood fire. As the water evaporated, the sorghum steamed and had to be stirred so it would not burn. Pictured from left to right are Urban Pinkston, Dalmon Pinkston, Ollie Gray, Donald Darland, and (by the post) Mitchell Reynolds. (Ollie Gray Pinkston Clark.)

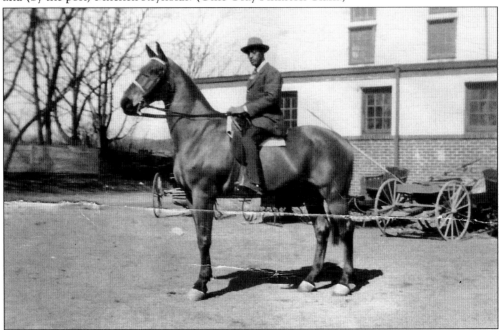

A LONG LINE OF HORSEMEN. Ray Walker learned his horsemanship skills from his father, who trained the world-famous Kalarama Rex. From a family of avid horsemen, Ray, his father, and his brother Charles Walker all worked at one time at Kalarama Farm. Ray worked at Kalarama for over a decade and then moved on to train horses all over Kentucky and Pennsylvania at prestigious horse farms. (Bettie Walker.)

THE OLD ARMORY AND 623. The Springfield National Guard Armory was the home of the First Battalion 623rd Field Artillery Service Battery. This unit was called up in the Korean War and during Desert Storm. A new armory was built in 1986. The old armory building houses the Washington County Emergency Medical Service and Springfield Fire Department. Pictured in front of the armory are some of Springfield's youth after a pickup basketball game.

KOREAN WAR PLAQUE. The brave soldiers listed on this plaque served in the Korean War as part of the First Battalion 623rd Field Artillery Headquarters Battery. The plaque is located next to the front doors of the Washington County Courthouse in Springfield.

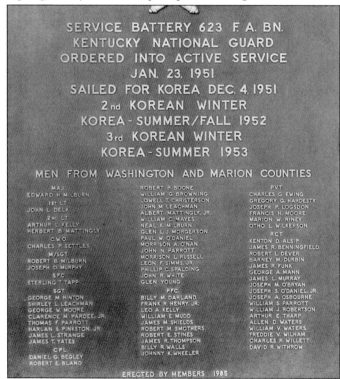

SERVICE BATTERY 623 F. A. BN.
KENTUCKY NATIONAL GUARD
ORDERED INTO ACTIVE SERVICE
JAN. 23, 1951
SAILED FOR KOREA DEC. 4, 1951
2nd KOREAN WINTER
KOREA - SUMMER/FALL 1952
3rd KOREAN WINTER
KOREA - SUMMER 1953

MEN FROM WASHINGTON AND MARION COUNTIES

MAJ
EDWARD H. MILBURN
1st LT
JOHN L. DELK
2nd LT
ARTHUR E. KELLY
HERBERT B. MATTINGLY
CWO
CHARLES P. SETTLES
M/SGT
ROBERT B. MILBURN
JOSEPH D. MURPHY
SFC
STERLING T. TAPP
SGT
GEORGE M. HINTON
SHIRLEY L. LEACHMAN
GEORGE W. MOORE
CLARENCE M. PARDEE, JR.
THOMAS F. PARROTT
HARLAN S. PINKSTON, JR.
JAMES L. STRANGE
JAMES T. YATES
CPL
DANIEL G. BEGLEY
ROBERT E. BLAND

ROBERT P. BOONE
WILLIAM G. BROWNING
LOWELL T. CHRISTERSON
JOHN M. LEACHMAN
ALBERT MATTINGLY, JR.
WILLIAM C. MAYES
NEAL K. MILBURN
GLEN L. J. MORGERSON
PAUL W. O'DANIEL
MORRISON A. O'NAN
JOHN N. PARROTT
MORRISON L. RUSSELL
LEON F. SIMMS, JR.
PHILLIP C. SPALDING
JOHN R. WHITE
GLEN YOUNG
PFC.
BILLY M. DARLAND
FRANK R. HENRY, JR.
LEO A. KELLY
WILLIAM E. MUDD
JAMES M. SHIELDS
ROBERT M. SMOTHERS
ROBERT E. STINES
JAMES R. THOMPSON
BILLY R. WALLS
JOHNNY K. WHEELER

PVT
CHARLES G. EWING
GREGORY G. HARDESTY
JOSEPH P. LOGSDON
FRANCIS H. MOORE
MARION W. RINEY
OTHO L. WILKERSON
RCT
KENTON D. ALSIP
JAMES R. BENNINGFIELD
ROBERT L. DEVER
BARNEY M. DURBIN
JAMES R. FUNK
GEORGE A. MANN
JAMES L. MURRAY
JOSEPH M. O'BRYAN
JOSEPH S. O'DANIEL, JR.
JOSEPH A. OSBOURNE
WILLIAM S. PARROTT
WILLIAM J. ROBERTSON
ARTHUR E. THARP
ALLEN D. WATERS
WILLIAM V. WATERS
FREDDIE V. WILHAM
CHARLES R. WILLETT
DAVID R. WITHROW

ERECTED BY MEMBERS 1985

CROSSING THE COLOR LINE. Pamela Spaulding Grundy was the first African American woman to cheer on an integrated cheerleading squad at St. Catharine College in 1972. A dutiful advocate for fairness and equality, Spaulding later became co-captain of the team. (Pamela Grundy)

DUE BILL COINS. Robinson and Walker General Store in Willisburg would offer long-term credit to customers. Farmers often settled their account when the tobacco crop came in near Christmas. Others kept their account current by trading eggs, fur skins, cream, butter, and country ham with storeowner Joe Robinson and his partner Joe Perkins, who started the "due bill" coins. Joe's wife, Mattie Jenkins Perkins, would give the customer a due bill coin if what the customer had to sell was more than the purchase cost or the balance on the account. Due bills came in 25¢ and 50¢ coins as well as in $1 coins guaranteeing the customer would come back and do business in the general store. The store burned down when an old oil heater was turned over in the early 1920s. (Billy and Betty Jane Cheser.)

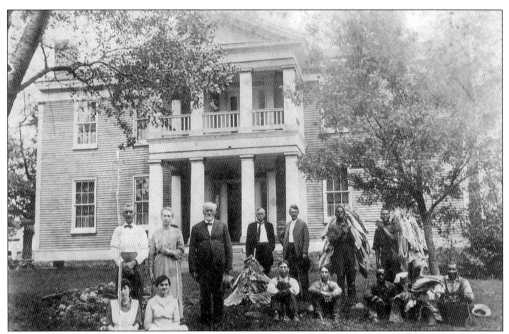

TOBACCO-CUTTING TIME. This picture of the Pope family at home on Shortline Road was taken during tobacco-cutting season, as can be seen by the sticks of tobacco on the ground and held by some of the men. Pictured from left to right are the following: (first row) two unidentified women, Charlie "Ethel" Pope, Lonnie Pope, Johnny Swann, and Will Clark; (second row, standing) Charles "Charlie" Bosley Pope and his wife Rhonda Dee Graves Pope, Reverend Purdon, Reverend Stallings, Sam Tucker, an unidentified man, and Willie Lee. (Larry Randolph.)

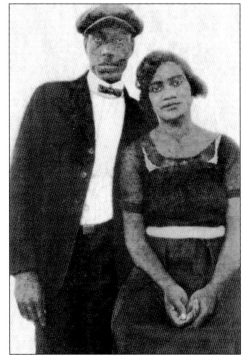

HARDWORKING COUPLE. This picture was taken on the wedding day of Ellen and Hubert Graves. Hubert and Arthur McGill were the first to work for the city sanitation department in Springfield picking up trash. Ellen Graves was a nanny, housekeeper, wet nurse, and domestic servant for the McWhorter, Barber, Haydon and Simms families in Springfield. In 1940, her pay was $1.50 a week plus two meals. (Nick McWhorter.)

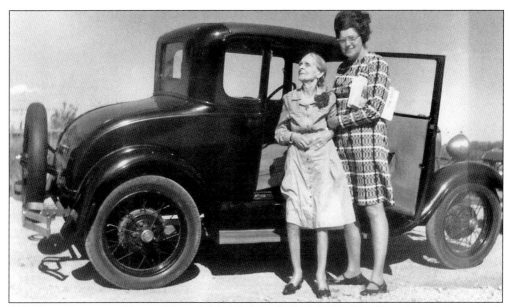

"A" Card Rations. Nanny Moore's Model A with the "A Card" still in the window, which denoted the days that World War II gasoline and food rations could be picked up. Nanny Moore was a nursing-home patient in Springfield, being cared for by Violet Elliott. The car is still in Washington County today on display at the Carey and Son Funeral Home. (Violet Elliott.)

Civilian Conservationist Corp (CCC). The U.S. Government created special forestry projects during the Great Depression of the 1930s and 1940s to provide people with work. Pictured are Joe Osbourn and Raymond Smith upon their return home to Springfield after concluding their work with the CCC. (Buddy and Joyce Taylor.)

PULLING TOGETHER. This horse-pulled tobacco setter was bought by Anthony, Thelma, and Betty Carrier along with Faye and Frank Carey. They shared the costs and the profits, helping each other set crops and harvest them. The tobacco setter required one person to drive the horses and two to sit in the back and drop the tobacco plants into the small ditch that was dug. (Violet Elliott.)

ALMOST AS TALL AS A MAN. Raymond Bottom is in his tobacco patch with his two sons and a tenant farmer inspecting the crop. When the tobacco is almost as tall as a man, Kentucky's cash crop is doing well. Tobacco money often arrived just in time for Christmas. (Bob Bottom.)

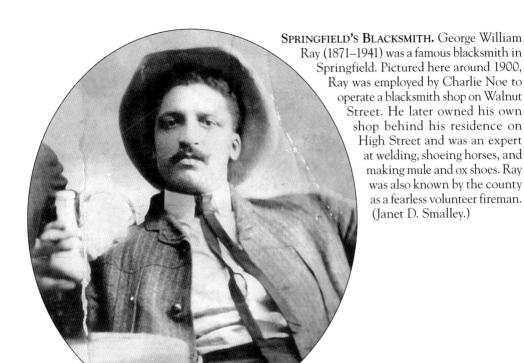

SPRINGFIELD'S BLACKSMITH. George William Ray (1871–1941) was a famous blacksmith in Springfield. Pictured here around 1900, Ray was employed by Charlie Noe to operate a blacksmith shop on Walnut Street. He later owned his own shop behind his residence on High Street and was an expert at welding, shoeing horses, and making mule and ox shoes. Ray was also known by the county as a fearless volunteer fireman. (Janet D. Smalley.)

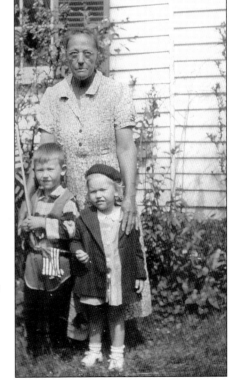

MARY RAY. Mary Ray took care of Tommy Haydon (holding the flag) and Pauline Haydon until young adulthood. Pauline later eloped at the age of 16. In the 1950s, Mary Ray worked exclusively for the Haydon family and was considered part of the family. She was paid $1 to $2 per week plus two meals. (Mary Barber.)

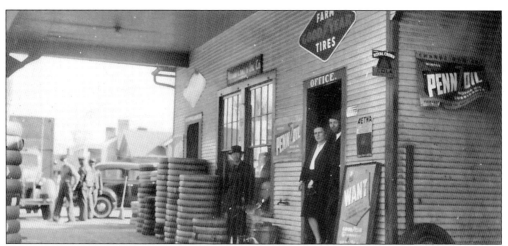

TIRES BESIDE THE OFFICE DOOR. Standing inside the office door at the Haydon Coal and Oil Company is company secretary Ellenour Haydon and George Lloyd Haydon. Customers are standing in the background. An unidentified man is standing beside the thin tires used on cars in the 1930s and 1940s. This station has a ladies' restroom, which was an uncommon sight at service stations in the 1940s. (Mary Barber.)

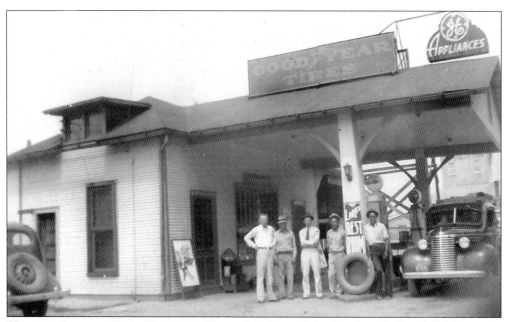

HAYDON OIL AND COAL COMPANY. Pictured in front of the Haydon Coal and Oil Company are Benjamin Haydon, George Lloyd Haydon, and Thomas Haydon. The two men beside the post are unidentified. In addition to coal and oil, the company sold lawnmowers, Aetna gasoline and oil products (later became Ashland Oil), Goodyear tires, and appliances. A coal tipple was located behind the company to offload coal for sale in town. (Mary Barber.)

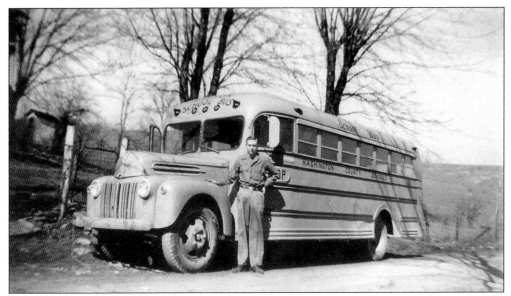

PROUD SCHOOL BUS DRIVER. Walter Wayne Jr. took great pride in his job, driving this 1940s school bus to pick up the children in Washington County. The school system was changed to a countywide one in 1966. Prior to that date, each town had an independent high school. The rivalry between the Willisburg, Mackville, and Springfield schools made for some very spirited sports competitions that sometimes spilled over into the parking lot. (Helen and Kenneth Gabhart.)

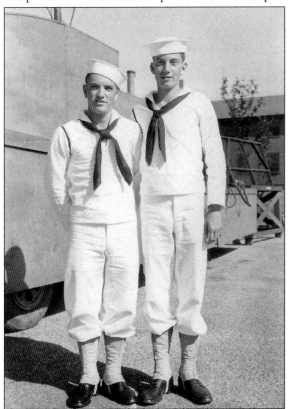

JOINING THE NAVY. Jody Cooksey and Colvin Brown joined the navy together in 1946. They served in Baltimore, Boston, and Norfolk Harbors. Calvin Brown retired and lives in Tallahassee, Florida. Jody Cooksey made his career at the Cowden factory in Springfield. He retired from the Tool and Designing Company and lives in Mount Sterling, Kentucky. (Billy and Betty Jane Cheser.)

MAIL DELIVERY. An unidentified man sits atop the horse-drawn U.S. Mail wagon that ran between Bardstown and Springfield. The mail came once a week. The wagon is marked "Nazareth Academy, U.S. Mail." (Joyce Taylor.)

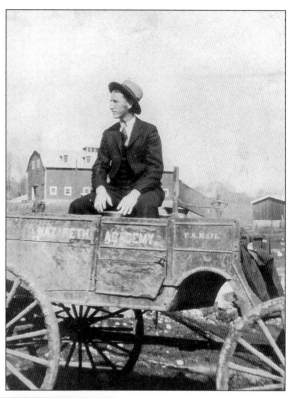

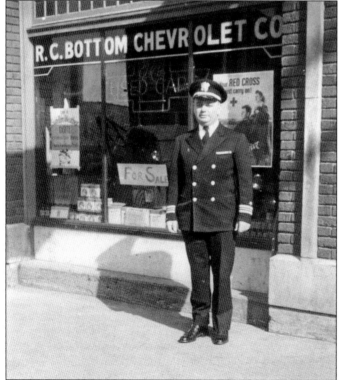

CHEVROLET DEALERSHIP. R. C. Bottom stands in front of his Chevrolet dealership in his service uniform. This building was built in 1954 after a fire at the Main Street garage (IGA Building). The new 7,000-square-foot showroom on Lebanon Hill Road displayed the 1954 Chevrolet model that had just arrived. Bottom died in 1970. (Bob Bottom.)

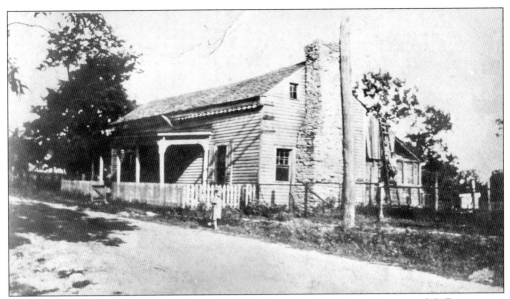

GETTING MAIL. The first post office in Mackville was in McGowan's tavern. McGowan was the first postmaster and first bartender. The mail was carried by horseback to the tavern every three weeks. The McGowan family was one of the first to settle the area in 1786. Visible (right) are two children climbing a ladder in 1912; identified is Lela Arnold (Rogers). The girl walking in front of the building is unknown. (Helen Gabhart.)

ACTIVIST. Kitty Ray Dawson, the youngest daughter of George and Betty Ray, is still living in Springfield. An activist since her early youth, Dawson felt it was her duty to join forces with fellow citizens and speak out on behalf of the African American community for the creation of sidewalks on High Street and for the preservation of the High Street School. She received the Women of the South Award for her work with the Community Action Council. (Janet D. Smalley.)

Five

AGENTS OF CHANGE

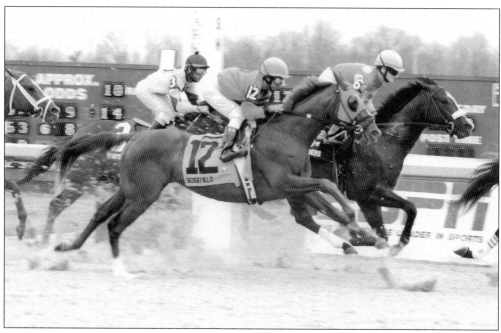

AN AMAZING RIDE. Sedgefield, ridden by Julien Leparoux, and Dominican, ridden by Rafael Bejarano, ran in the 133rd Kentucky Derby. Darin Miller trained both horses. Dominican is named after the Dominican order of nuns at St. Catharine. Pictured here is Sedgefield, owned by Tommy and Bonnie Hamilton running fourth (wearing number 12) in the Transylvania Stakes race. (Jeff Moreland and the *Springfield Sun*.)

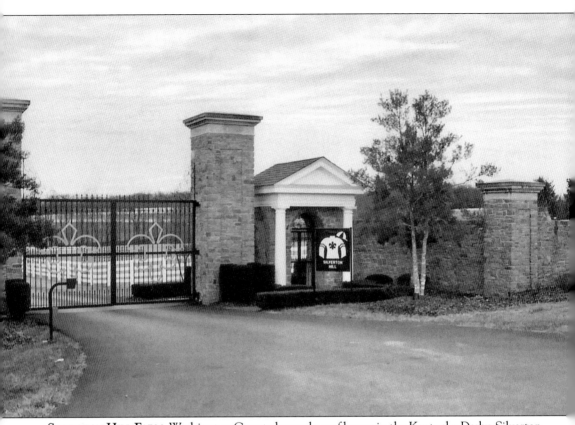

SILVERTON HILL FARM. Washington County has a place of honor in the Kentucky Derby. Silverton Hill Farm, owned by Tommy and Bonnie Hamilton, had their horses Sedgefield and Dominican in the 133rd running of the Kentucky Derby on May 5, 2007. It was the first time Washington County had ever had a horse in the derby. The sprawling 1,500-acre Thoroughbred horse farm is located on the outskirts of Springfield.

THE WALTON HOTEL. Sensing the ticking clock, people openly lament the passing of the old Walton Hotel. Built in 1902, this luxurious hotel was named for Gen. Mathew Walton, known as the political father of Springfield and Washington County. The hotel stood on Main Street across from the Washington County Courthouse until it was razed in 1990. A $13-million judicial center will be built in its place. (Teddy M. Boone)

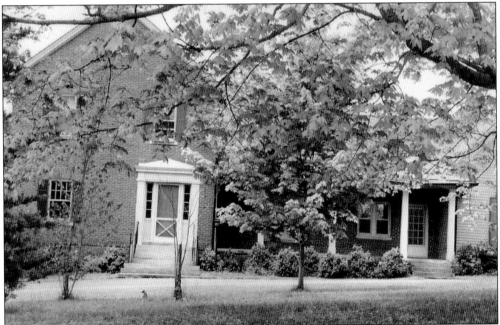

ELEANORES. Elizabeth Maddox Roberts built this neoclassical brick home. After returning to Springfield, she wrote *The Great Meadow* and *Time of Man*. With the proceeds from her international book sales, she built Eleanores. She lived there until she died, and she is buried in the Springfield Cemetery.

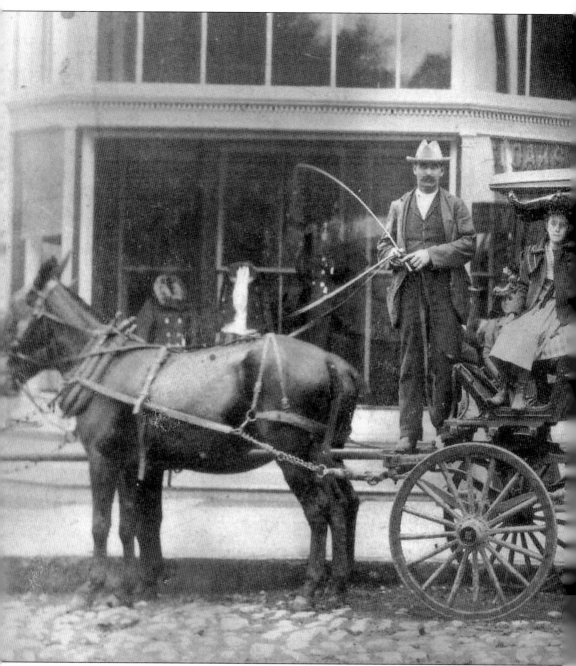

RIDING TO ST. CATHARINE ACADEMY. St. Catharine Academy was a significant and historical agent of change in Washington County. The academy was noted for the outstanding education it offered in 1843, as it had courses that were not available in other parts of the county, including history, philosophy, composition and the fine arts, grammar and rhetoric, French, geography, botany, music, and drama. These 17 young girls are being picked up by the academy's driver in a mule-drawn wagon to attend school a few miles away. They were taught by the Dominican sisters of St. Catharine Motherhouse. Some of the girls in this photograph represent the oldest and largest families in Washington County. This picture was taken around 1885 on the cobblestone

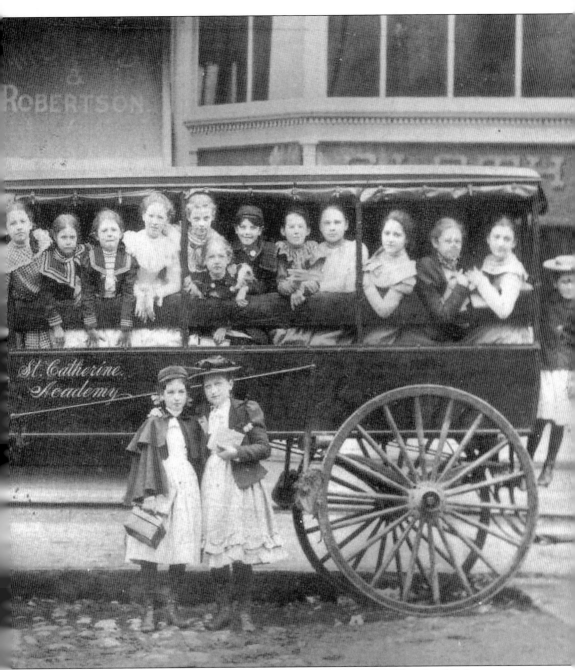

and dirt road combination of Main Street in Springfield in front of McChord and Robertson, the clothing and fineries store. A woman exiting the store can be seen near the front of the buggy. Notice the period clothing being displayed in the storefront window. From left to right are Mary Haydon, Emily Russell, Mabel Price, Louise Hayden, Margaret McChord, Edna McLaughlin, Jenny McCabe, Isabelle Medley, Jenny Green, Lara Carter, Gertrude Shader, Edith Price, Allethaire Medley, Myrthe Price, and Nellie Green. Standing in front of the wagon are Flaget Simms and Louise Medley. (Sr. Rosemary Cina and St. Catharine Motherhouse.)

TRAINER OF KALARAMA REX. Joseph Walker, of Springfield, trained Kalarama Rex to win the national champion Saddlebred award. He worked at Kalarama Farm, caring for the horse for the 22 years of its life. Walker was not allowed to ride the horse in competition due to racial barriers and trained Frank Bradshaw to do it instead. He rode a mare from Springfield to Lexington to have it bred. The journey took a week. (Bettie Walker.)

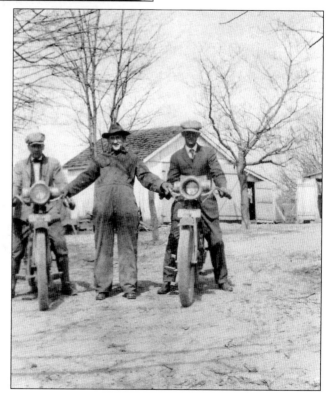

FIRST MOTORCYCLES IN THE COUNTY. Riding two of the very first motorcycles in Washington County, Bill Russell (left), John M. Spaulding (holding bikes), and Reed Spaulding leave for Lebanon and St. Mary's from Springfield after a baseball game on Sunday, April 11, 1920. Reed Spaulding is the father of Taylor and Reed Spaulding of Springfield. (Taylor Spaulding.)

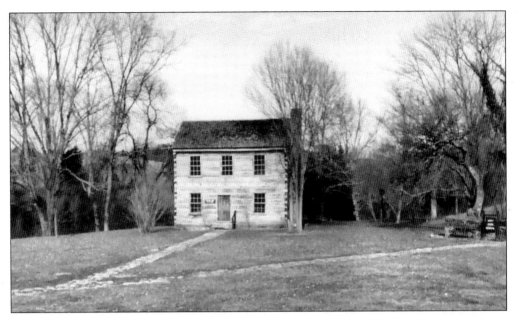

THE BERRY HOUSE. A replica of the Berry House is located at the Lincoln Homestead State Park. Nancy Hanks lived in this home when she was courted by Thomas Lincoln, who proposed to her in front of the large fireplace. The marriage of Nancy and Thomas Lincoln occurred on this spot in 1806 and forever changed Washington County's place in history.

LINCOLN CELEBRATION. In preparation for the National Lincoln Bicentennial Celebration, which will take place all across the county in 2009, Washington County reenacts the 200th anniversary of the marriage of Thomas Lincoln and Nancy Hanks in 1806. Pictured here are actors portraying Nancy Hanks and Thomas Lincoln taking their vows with Tom Berry alongside at the Lincoln Homestead State Park. (Jeff Moreland and the *Springfield Sun*.)

POPE HOUSE. John Pope (1770–1845) was a Kentucky lawyer and statesman from Springfield who married into wealth when he wed Gen. Mathew Walton's widow. He served in the U.S. Senate, as Kentucky's secretary of state, in the Kentucky Senate, and as governor of the Arkansas Territory. He was named by President Jackson to the U.S. Congress. A Federalist and Democrat, he built this home in 1839, died there, and is buried in the Springfield Cemetery.

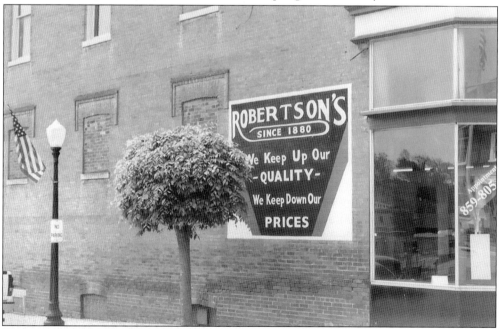

ROBERTSON'S. Built in 1880, Robertson's dry goods store was the place to come for fineries that were not offered in the local community stores. Robertson's was the place to go for a new dress or suit. This advertisement, on the side of the brick wall where the store originally did business, was painted by Dal Drury as part of a historic renovation plan instituted by the City of Springfield.

DOCTOR HOPPER'S BAG. This bag belongs to family doctor, Joseph Hopper, who improved the quality of life for Washington Countians and delivered most of the babies in Willisburg with his midwife, Mary Grider. The bag still contains many of the instruments and original medicines used by the doctor. It is housed in the Main Street Museum, run by Wayne Pinkston.

RENAISSANCE OF THE SPRINGFIELD OPERA HOUSE. Restoration of the opera house, which was built around 1900, was completed in 2005 as part of the Downtown Renaissance Project. Former governor Paul Patton dedicated the newly renovated building in 2006. Mayor Mike Haydon and city council members—Paul Borders; Mike Elliot; John R. Hardin; Willie Ellery; Carolyn Hardin; Mary Haydon; and Bill Robinson, city attorney—are listed on a plaque on the outside of the building as contributing to the success of the renovation project.

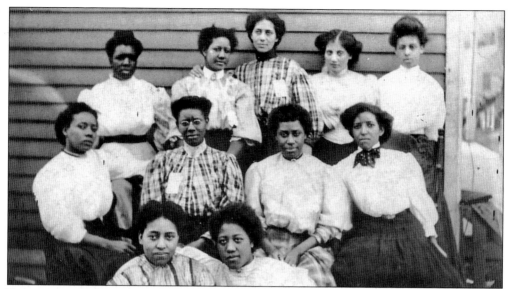

EDUCATION AT HIGH STREET SCHOOL. This picture of the women's club members was taken *c.* 1900 during school segregation. Seated on the first row, second from the left is Mary Clark. Seated on the second row, first on the left, is Anna Phillips, a teacher and the principal of the High Street School for over 50 years. Standing on the third row in the center is Betty Casey Ray. (Janet D. Smalley.)

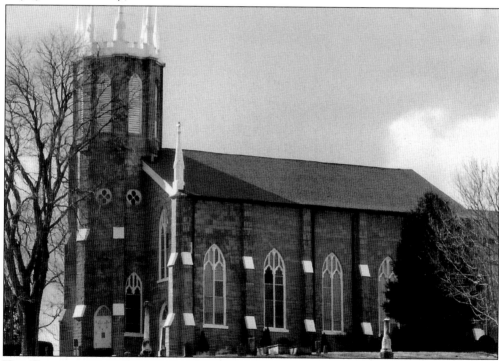

THE CENTER OF THE COMMUNITY. St. Rose Catholic Church was a major element of change in the county, and it created a large part of county's identity for almost two centuries. It was the community's social fabric, offering entertainment, sports leagues, picnics, dances, religion, education, religious vocations, and opportunities for young people to meet. (Mary Lynn Clark)

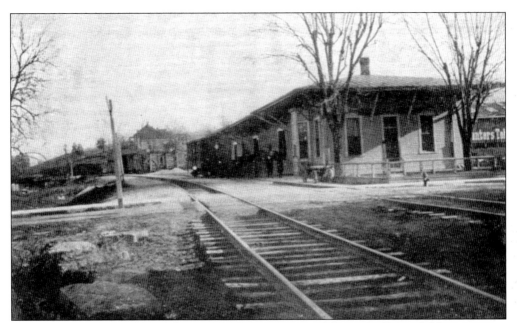

THE OLD SPRINGFIELD TRAIN STATION. This 1922 postcard shows the Springfield train station in its heyday. The train offered a "spur line" (short line originating from a larger line) between Bardstown and Springfield. It was the fastest mode of travel, allowing folks to go to the larger cities and shop. In 2005, the City of Springfield acquired the site and replicated the train station's architecture in a new farmers' market. (Helen and Kenneth Gabhart.)

RAILROAD TRESTLE. Pictured here is a train trestle made of wood; part of the spur line between Springfield and Bardstown was often filled with hay, people, and fertilizer. The train meant mobility, change, and opportunity for the more rural areas of the county. The trestle was torn down in the late 1980s, after the spur line was abandoned by Louisville and Nashville Railroad. (Teddy M. Boone.)

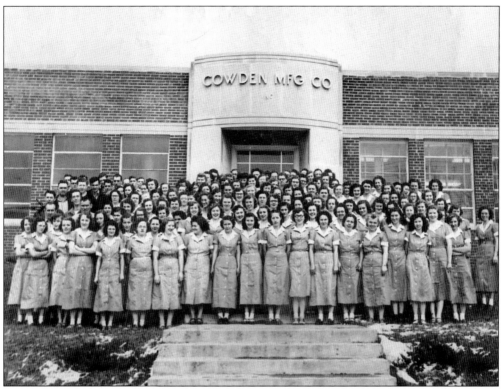

OPENING DAY. The Cowden Manufacturing Company plant opened its doors on October 4, 1949, in Springfield. It was the first big factory in Springfield and brought industrial change and 175 new jobs to the county. Pictured here are the original employees in uniform on the front steps of the plant. It was the fourth plant and newest of eight Cowden Manufacturing operations in the state at that time. (Mary Helen Russell.)

SMALL-TOWN TRUST. This check signed by G. L. Foster is written in pencil for a $1.35 purchase of gas and a fan belt. Blank checks for each bank in town were kept at the counter for customers. Names, not account numbers, were used. A customer could even use a pencil to change the name of the bank to another bank's name, and it would still be accepted. (Billy and Betty Jane Cheser.)

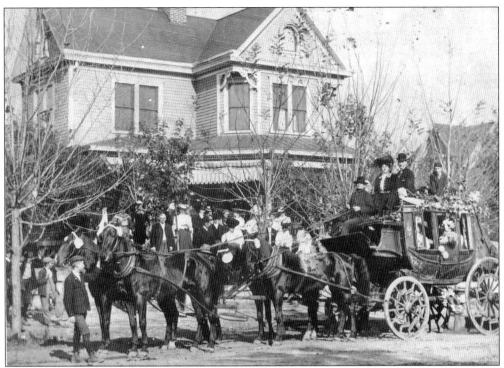

YIELDING TO CHANGE. Charlie Moore owned and operated the stagecoach in Springfield. Its services later yielded to "Tin Lizzie," the spur line train. This picture, taken in 1905, is of the wedding of Mary Avritt Lewis, daughter of Mr. and Mrs. John W. Lewis, and Fred Manget, of Louisville. The coach and horses were decorated with white ribbons. (Gwinn Hahn and Devola Moore Haag.)

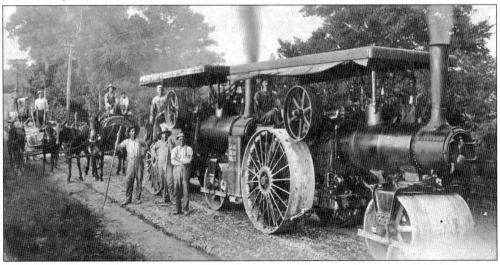

BUILDING A ROAD. New roads changed the landscape and increased accessibility for the county residents. This steam engine was powered with wood and coal that was hauled by a team of horses, called Bill and Bob. Gravel hauled from the Springfield quarry and tar that was spread by hand were used to build a road between Springfield and Willisburg in 1926. (Gwinn Hahn and Devola Moore Haag.)

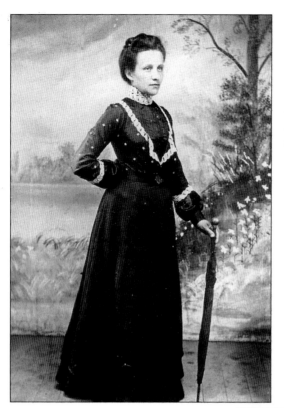

THE WOMEN OF WASHINGTON COUNTY.
Washington County's women were
charged with keeping house for the
many children they bore, watching as
some passed away because of unavailable
medical care; working in the fields; and
fighting for the right to vote. They were
sometimes constrained not only by the
corsets they wore, but also by society's
expectations. (Nick McWhorter.)

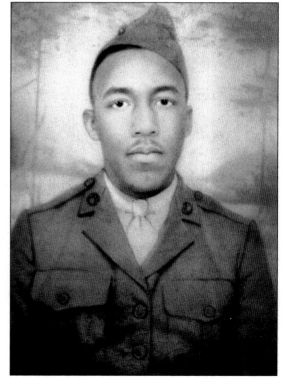

BREAKING RACIAL BARRIERS. Born
in Springfield in 1921, Edward Polin
enlisted in the U.S. Marine Corps in
1942, one of the first African Americans
from Kentucky to become a "Montford
Point Marine," the corps' first training
unit for blacks. Polin died in 2006 while
still a resident of Springfield. (Kentucky
History Center.)

Marine Corps Dress Uniform. Edward Polin joined the marines because he admired the discipline of the corps. Polin donated his dress uniform to the Kentucky History Center, in Frankfort, for a special exhibit of artifacts called African Americans in the Military, which took place in September 2006. He was one of the first African Americans from Kentucky to enlist in the marines during World War II. Polin died shortly after the exhibit. (Kentucky History Center.)

Washington County Delegate. William C. McChord was a delegate from Washington County. McChord was involved with the railway industry in Kentucky, and his writings are available at the Kentucky History Center. This picture was taken from the album of C. J. Bronston, from Lexington, also a delegate to the Kentucky Constitutional Convention of 1890–1891. (Kentucky History Center.)

BLUEGRASS PARKWAY IN WASHINGTON COUNTY. Opened in 1966 as a toll road, the Bluegrass Parkway was the link for Washington County to the larger cities of Lexington and Elizabethtown. In 2005, it was renamed for Kentucky's first female governor, becoming Martha Layne Collins Blue Grass Parkway. An 83-mile-long controlled access highway, it is one of nine highways that are part of the Kentucky parkway system. (Kentucky History Center.)

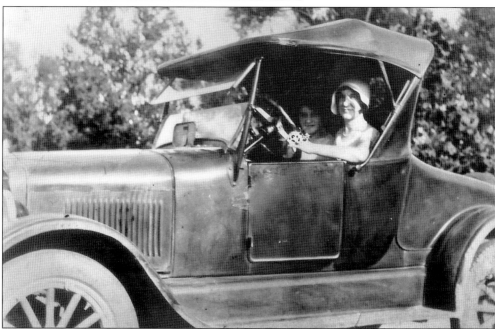

BREAKING THE MOLD. Stella Masters (at the wheel) was a groundbreaker for future generations of women in 1929. She did not follow the pattern of marriage and family for young women at the time. She owned her car and had a job as a schoolteacher. Should she have married, she would have been required to leave her job. Also seated in the car is Ava McMillan. (Violet Elliott.)

PIONEER FAMILIES. The courageous pioneer families that settled Washington County helped fashion it as it is today. Henry Keeling (1837–1894), who had a hand abnormality, and Sarah Calvin Keeling (1842–1887) sit with their baby placed on top of a book on her lap. The baby is playing with a funnel. (Billie and Betty Jane Cheser.)

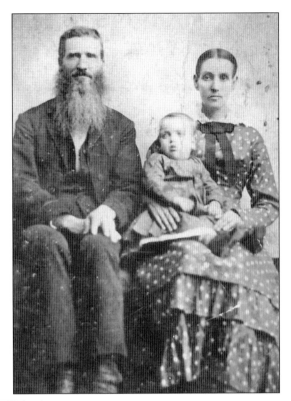

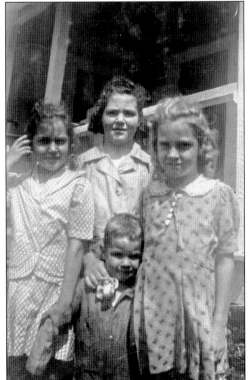

THE COUNTY'S BEST ASSET. Children are the agents of change and are the biggest asset of Washington County. Enjoying a relaxing summer day, from left to right, are Jane, Joyce, Jack, and Patricia Osbourn in front of their house on St. Rose Street and Lebanon Road. The Osbourn house was passed down for three generations. (Joyce Taylor.)

ACROSS AMERICA, PEOPLE ARE DISCOVERING SOMETHING WONDERFUL. *THEIR HERITAGE.*

Arcadia Publishing is the leading local history publisher in the United States. With more than 3,000 titles in print and hundreds of new titles released every year, Arcadia has extensive specialized experience chronicling the history of communities and celebrating America's hidden stories, bringing to life the people, places, and events from the past. To discover the history of other communities across the nation, please visit:

www.arcadiapublishing.com

Customized search tools allow you to find regional history books about the town where you grew up, the cities where your friends and family live, the town where your parents met, or even that retirement spot you've been dreaming about.